A Scottish Graveyard
Miscellany
ഌൟ

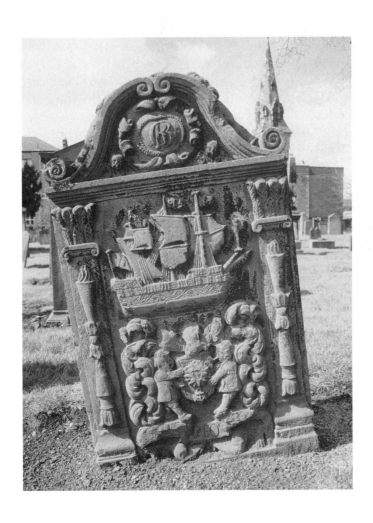

Hamish Brown is a well-known outdoors writer, lecturer and photographer who has written several bestselling books, including *Hamish's Mountain Walk, The Mountains Look on Marrakech, Along the Fife Coastal Path* and *Exploring the Edinburgh to Glasgow Canals.* He is also a regular contributor to the Mercat Press *25 Walks* series. He divides his time between his home in Fife and Morocco, where he leads expeditions in the Atlas mountains.

1. (Previous page) This ornate stone is in Perth Greyfriars, one of the special stones under protective cover.

A SCOTTISH GRAVEYARD MISCELLANY

Exploring the Folk Art of Scotland's Graves

ഌ❧

BIRLINN

First published in 2008 by
Birlinn Limited
West Newington House
10 Newington Road
Edinburgh
EH9 1QS

www.birlinn.co.uk

ISBN13: 978 1 84158 676 2

British Library Cataloguing-in-Publication Data
A catalogue record for this book is available from the
British Library

Typeset in ITC Galliard at Birlinn

Printed and bound in Great Britain
by Bell & Bain Ltd, Glasgow

Contents

ഇൗരു

Acknowledgements

As mentioned in the Introduction, my biggest debt is to Betty Willsher, the original gravestone expert for many of us, and Ann Watters and the Kirkcaldy Civic Trust were early influences locally. Alan Morrison of Crosbie Matthew Funeral Directors in Kirkcaldy kindly briefed me on current funeral practices. Jill Adam, Perth, explored many sites with me and often proved the better observer. Ronnie Leask provided knowledgeable tours of Edinburgh graveyards and other sites, and the staff at the Dean Cemetery were helpful in locating certain stones. A thank you to the lady who sent on Monifieth details. Kate McLaren provided the picture of the Boy Scout after one slide show, and many people gave other interesting bits of information. Dougie Waddell (Snappy Snaps) in Queensferry Street, Edinburgh gave photographic labours beyond the norm and Black and Lizars duplicated slides when nobody else could. Syd Scroggie gave me the Glen Prosen rhyme, Lady Glengarry the picture of the raven. I'm also grateful to Betty Willsher for permission to quote her on topics and sources I've not personally encountered, and both the National Library of Scotland and Edinburgh City Library provided books I'd not have seen otherwise. Thanks too for some recent authors: Norman Adams for some startling notes in his *Scottish Bodysnatchers* (Goblinshead, 2002), David Hunter for the survey booklet on Barr's pleasant burial ground, Dane Love for *Scottish Kirkyards* (Hale, 1989), the re-reading of which brought back forgotten references (it is still the only other general book on the subject); and Michael Turnbull's *Edinburgh Graveyard Guide* (St Andrew Press, 2006) which I have only recently bought, a booklet which would be very helpful to anyone starting to look at interesting stones about people in easy to reach sites. Lastly, a special thank you to Sheila Gallimore who typed and made presentable a complex and much corrected manuscript.

For Jill
companion on many kirkyard explorations
and Betty
who showed the way

Introduction

ഇ)രുള

Reader, one moment
Stop and think
That I am in eternity
And you are on the brink.[1]

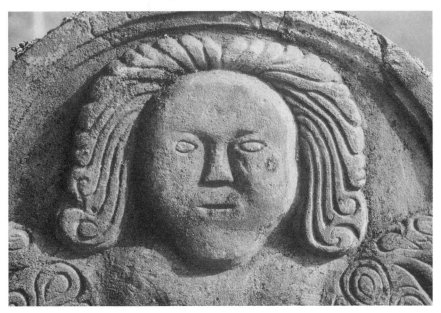

2. A splendid head on a stone at Peebles.

The title of this book perhaps conveys the fact that I'm an enthusiast rather than an expert on the subject of Scottish graveyards, but then the book is not aimed at the expert. I've simply enjoyed looking at graveyards for many decades (about ninety sites appear in this book's illustrations) and having amassed some thousands of slides felt I really had to put together a slide show ('lecture' sounds a bit formal) with the title *Guddling among the Graves*, one which, while giving plenty of factual information, would also be entertaining. Our eighteenth century stones, with their delightful folk art, are a unique treasure with all the appeal of old Pictish stones from which, indeed, they may well have

drawn some inspiration. This treasure is under threat from weathering, neglect and vandalism and a lack of legislation for their preservation. Some publicity, some popularising can do no harm.[2]

Having said that, however, the sheer oddities I encountered, the range of discovered topics and the not so grave humour that kept breaking in, plus the need to set the scene, soon led to the slide show splitting into two sessions, part one giving much of the background, part two concentrating on these gems of earlier years. The formula seemed to work, for after every showing of part one, there was a demand for part two and also suggestions that there should be a book – so here it is. The book covers more ground while keeping to roughly the same order. If readers find enjoyment following up what they read I will be well rewarded. One library (which had better be nameless) did a poster for the *Guddling Among the Graves* slide show but the wording came out as *Cuddling Among the Graves*. Did this increase the audience numbers, I wonder? One old man certainly told me, rather shyly, that he had done his courting in his local graveyard.

Kirkyards are not to be shunned; they are not gloomy, spooky spots, despite the yew trees, rampant ivy and decay. (Do you know *why* the yew trees are there?) Graveyards offer an entertaining way in to all sorts of historical and social exploring. Set the children searching for the oddest name, their own name, for the oldest person – and then watch. They will soon learn that graveyards are fun. Show them a stone with a spelling mistake. List all the different flowers that can be recognised on stones. The title of my slide show is not so bad a choice, not that there aren't heartbreaks too. I have sometimes stood numbed with shock. Nobody could stand unmoved before the circling group of children's graves on a hillside above Dunblane.

This book gives a selective collection of explanations, anecdotes and stories, partly chronologically, partly zigzagging back and forth over the centuries, and could have been expanded hugely; but I hope the examples and explanations will help in understanding what can be seen, and the stories show what can be discovered in any setting. I am much indebted, as is anyone with graveyards curiosity, to Betty Willsher and Doreen Hunter, whose book *Stones* (Canongate) became *the* authority on the subject when published in 1978. A booklet on the subject *Understanding Scottish Graveyards* by Betty Willsher is currently in print, published by the Royal Museum of Scotland, and the museum itself has an excellent section on the subject of Scottish graveyards and attitudes to death.

The work done by William Wolsey and William Anderson and the Kincardine Local History Group in restoring and recording the stones in the graveyard at Tulliallan (Kincardine) was a revelation and is a model for others to follow. If I was reduced to just one graveyard it might well be my choice. Most of what follows is from my own observations or research; if not, I try to give the source (not always known) or location. I dare not leave these out or I'll be taken to task by those who want specific places named.

A word of warning. Just as guidebooks to Scotland always show blue skies (and no mention of midges) the pictures in this book can flatter to deceive. I've taken pictures of the best, the gems among the dross, and on sunny days when the images were clear. It is not always like that.

What is actually inscribed on a gravestone is given *in italics* and the location mentioned. If the graveyard is difficult to find, and for those recommended at the end, a six figure reference will be given from the appropriate O.S. Land Ranger map. A stroke (/) between words in a quotation indicates the end of a line in the original. 'Gravestone' is usually abbreviated to 'stone'. A graveyard/kirkyard is always round a church; unlike a cemetery. A church name, unless specified otherwise, will be the parish church or an isolated church not likely to be confused with any other. Sometimes a church, if open, will have a leaflet/booklet about the church and/or graveyard, so be sure to check, and this applies to local museums and tourist information offices. Eighteenth century refers to the dates between 1700 and 1799 (not those with 18-something as is often supposed).

There is now a steady growth in having gravestone inscriptions recorded, but few of these records give any indication of what appears on the stone other than the words. These may be vital for genealogists, but even for them a note of the artistic work would aid in finding a stone and be invaluable for the many, like myself, who are primarily interested in the folk art element. Recorders please note. The Bible verses appearing on stones are invariably in the 1611 King James Version, there being few other versions before modern times.[3]

I did have a slight worry that surveying this topic might give instances of offence, but feedback has been entirely positive. (One writer said my slide show had been the first step back to normality in her sad experience of bereavement.) The subject after all, concerns everyone, and to smile – however wryly – is surely the best positive when faced with the ultimate negative.

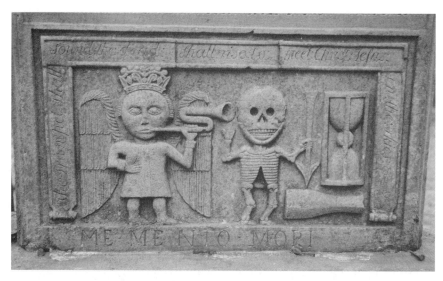

3. A resurrection blast at Death; Logie Pert.

Curiously, this book was largely written in Morocco, between various Atlas wanderings and busy historical research out there. However good my memory, many blanks had to be left so I could check spellings, note details only available on my slides, insert map references and much else. Discoveries, research, could go on for ever (and no doubt will), but I've had to hand over the work at this point. If any errors result, I apologise – and would welcome corrections, additions and notes about curiosities of any kind. I've tried to answer all the regular questions I've been asked over the years. My feeling on letting the book go is that there is 'nowt so queer as folk' – and how little we have changed in expressing grief over the years. Death deals with all the differences. I've seen a German sailor in a British war cemetery, Muslims and Jews in Christian graveyards. Under the earth all are beyond strife; peace on earth, it seems, is only hard for the living.

PART ONE
The General Background
ഇൗരു

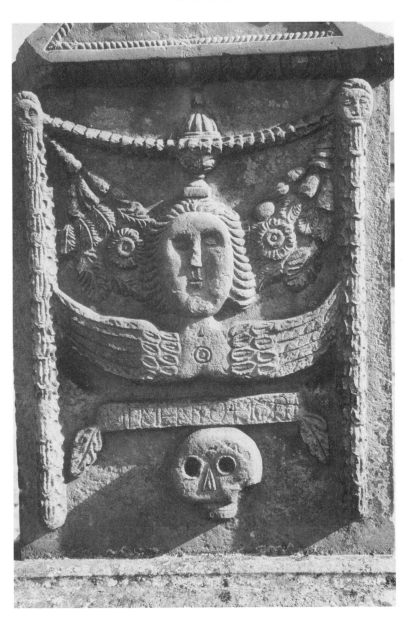

4. (Previous page) This striking stone is in Peebles, to the right on entering the kirkyard.

Earlier History

ഗ∂രെ

5. *Torphichen.*

WANDER round the graveyard of Abbotshall Church in Kirkcaldy and you will likely pause before a grave where there is a striking figure of a young girl sitting with a book on her lap, inscribed 'Pet Marjory' (*fig. 6*). Surely a story here? Yes—and a deal of myth as well, for Marjory Fleming was never known by that sentimental appellation in her brief lifetime. She died at the age of eight, and the truth is more interesting: she is Scotland's youngest literary person of note. Her writings were gathered after her death (1811) and have seldom been out of print since.

She wrote letters and poems to a cousin in Edinburgh and kept a diary (in which she scandalously once used the word 'damn'), a diary of inconsequential childish innocence and the odd mention of contemporary news—Napoleon's doings for instance. Recovering from measles, she developed meningitis which proved fatal.

The myths then began, but owe most to Dr John Brown (buried in Edinburgh Carlton New), who is himself best known for his dog story 'Rab and his Friends', and whose volumes of essays, given the title *Horae Subsecivae,* were popular. He dreamed up such stories as that Marjory was carried snugly in Sir Walter Scott's plaid in Edinburgh (they never met) and he gave her the 'Pet Marjory' tag. Though well-acquainted with this, because aware of all this, I had to smile recently when wandering round Cupar New Cemetery. There was a cross to James Fleming Bremner, a Fifeshire Chief Constable – but that distinction was not the memorable fact; below was added 'nephew of "Pet Marjory"'.[4]

As a storyteller such myth-making appeals to me, however it rather clashes with my constant demand to know historical exactitudes, a much harder terminal. In this book I mention something like 180 graveyards (and goodness knows how many stones)—most of which I have visited —and, while truth and fancy are easy to separate in something like the Pet Marjory story, problems of interpretation increase as we regress through the centuries. This give me a good excuse *not* to go far back, besides which there is a purely practical reason: graveyards as we think of them only came into being in the sixteenth and seventeenth centuries, and, starting there, the subject will still make for a larger book than originally envisaged.

I would like to delve back to prehistory, to the times of the Picts and through mediaeval centuries (people after all were dying and being buried, often in graveyard equivalents) but must push on.[5] Eventually, where there were churches, notables (and only notables) were given recorded burials and these were inside the churches, the fact recorded on a floor slab or one set against a wall. Even though the population was

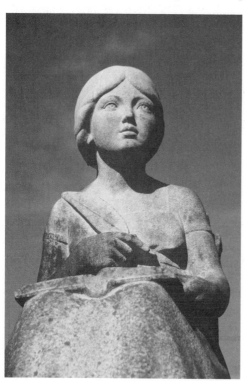

6. *'Pet Marjory' of literary fame.*

small, grew slowly and had appalling setbacks (like the Black Death), floor and mural space was limited. The 'house full' signs rather fortunately coincided with the Reformation with its many new ideas, attitudes, and changes to practices.

In 1581 burial within a church was no longer allowed, though implementing the law was not easy. In 1595 the right to enclose land round a church entered the statute books (and has never been repealed!) and often this was, literally, a God's Acre, and sometimes walled off in as round a shape as possible to ensure that were no corners where the devil could hide.

There was resistance from some of the nobility over *having* to move out but—apart from the problem of space—the reformers had felt a church was not the best place to act as a mausoleum. Out everyone went. As a result the earliest stones in graveyards tended to be slabs very similar to what had been inside, whether on floor or wall. Many great families regarded moving out as infra dig, and true to character managed to get round the problem: they built *aisles*, as they were called, miniature or not so miniature buildings which would abut against the church, as near as they could get to what had been allowed before. (Haven't we all seen children, told NO to something, work as close to it as they dare without incurring parental wrath?)

Inscriptions inside, especially of ecclesiastics, had nearly always been in Latin, but after this change Latin was slowly replaced by English. Political and religious correctness probably was the main reason, but no doubt there was a touch of vanity: everybody could now read of their doings. The use of Latin later was inverse snobbery. If I often seem to be saying 'nearly always, probably, perhaps' in this book, this reflects how little we do know. There haven't been many PhDs on Scottish graveyards.

While aisles became mausoleums for the upper echelons of society, changes also occurred in the graveyard. The flat stones on the ground became overgrown, got walked on, damaged and weathered quickly, so very soon they were put up on legs and became table stones. These could have between four and eight legs, and the space between the legs may or may not have been enclosed with slabs. Six legs and no panels is by far the commonest version. (The enclosed versions were sometimes called altar graves or chest tombs.) Instead of a flat surface, by raising the top of the table slab to a pitched roof shape (a coped stone) as many as five facets could be created which gave far greater scope for decoration. There's a splendid example at Scoonie (Leven)[6] with a skeleton

7. Ornate legs on a Kirkcudbright table stone.

along the ridge and intricate text and decoration on every other surface (see also *fig. 65*). There's an attractive array of mossy tablestones at Tweedsmuir's rural graveyard in the Borders, and they proliferate at Glamis, Torryburn, Dairsie, Tulliallan (Kincardine on Forth), Duffus (Moray), Kirkcudbright and many, many places.

Walling a graveyard/cemetery had other spin-off effects, one being that those who might have aspired to a mural monument inside the church could still indulge their fancy against the graveyard wall. Many examples exist, from the rather battered early sites (like Crail) via Edinburgh Greyfriars to the Victorian swank of the Dean. A 1707 stone at Innerpeffray (west of Perth) is in a class of its own, full of family portraiture and detail (a delightful contrast to the Bruce Aisle mentioned on p. 75, *fig. 64*). It has now been moved inside the old chapel building to prevent weathering.

Another use for graveyards explains the frequent presence of yew trees. Yew trees are poisonous to cattle (and humans) so, before the time of the enclosures, when cattle wandered about everywhere, the graveyard was the obvious place to grow yew trees (*fig. 8*). They were important for producing the wood used in bows and many a bow butts (archery practice ground) was sited in a graveyard. Crail Church has grooves on a corner of the building where arrow points were sharpened

8. An old aisle with attendant yew trees beside Loch Leven (Kinross).

9. A highly decorated table stone at Pencaitland.

10. A simple cemetery on Hirta, St Kilda.

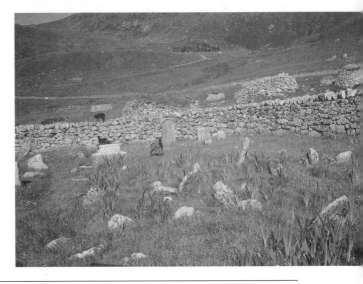

up. James I (d. 1437) had to issue a ban on such trivial games as golf and football in an effort to see archery practice was not neglected. James II (1457), James III (1471) and James IV (1491) had no greater success with the acts they passed in those years. The oldest living thing in Britain is a yew tree in the graveyard at Fortingall (Perthshire) which is something like 3000 years old.

Early stones tended to be just that, as in St Kilda graveyard (*fig. 10*) and there was no writing on them. When graveyards as we know them began there was quite a bit of experimenting as already mentioned. Sometimes the stone was shaped like a coffin. There's a splendidly decorative one outside the entrance to Glasgow Cathedral, and at Ratho there's an often-pictured one for its exact likeness to a coffin, even to the panels and brass handles. The incumbent suffered an *instantaneous death from the stroke of a thrashing (sic) machine* (early nineteenth century).

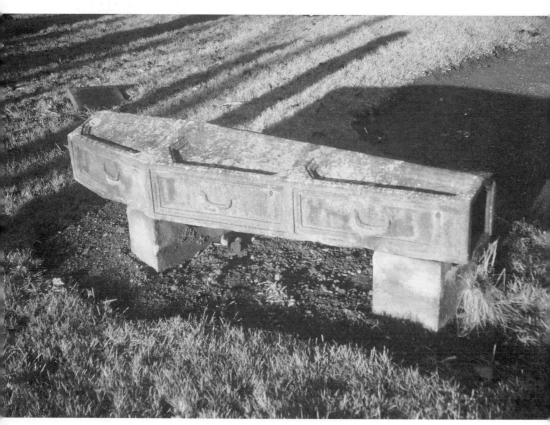

11. Coffin-shaped 'stone' at Ratho.

Of Aisles and Mausoleums
ಕಾಲ

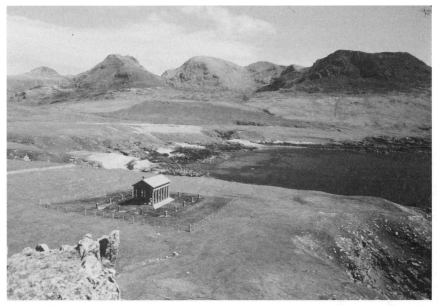

12. *The mausoleum on the Island of Rum.*

To know man's life, keep Death still in your eye. (Tranent)

AN early aisle, the Charteris Aisle of 1598, can be seen at Kinfauns. The church is a ruin (replaced nearby) so the aisle dominates.[7] Many of them do, too many really, for they were often simply an expression of pomp and power. Very OTT (over the top). One I came on recently was at Larbert Old, a Greek temple-like edifice for a Keswick-born industrialist, Dawson, who ended as manager of the Carron Ironworks. Many were the burial places of old noble families, of course, like the Moray Chapel, as it is called, at Donibristle. The bonnie earls of Moray from the seventeenth to the nineteenth century were interred here. One was reputedly a giant, and when the floor collapsed or whatever so the coffins could be seen, one was found to be nine feet long.

The most strangely situated mausoleum has to be another—miniature —Greek temple at remote Harris on the island of Rum, the resting

place of the Bulloughs, Edwardian industrialists from the English Midlands, who had bought the island and built Kinloch Castle. The widow of the last Bullough sold the island to the then Nature Conservancy. I had a school party staying at Harris when Lady Bullough was brought there for burial. The setting is beautiful beyond the telling (*fig. 12*). But a Greek temple!?

> *Here lies the Laird of Lundie*
> *sic transit gloria mundi.*[8]

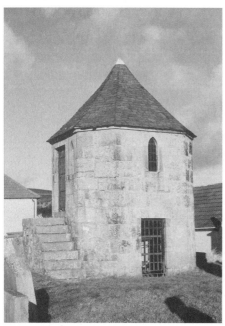

*13. The Kilsyth mausoleum/
watchhouse.*

One mausoleum (which was also a watchhouse) with a weird story is at Kilsyth (*fig. 13*). Jean Cochrane, a granddaughter of the Earl of Dundonald, had married Bonnie Dundee who was killed in his moment of victory at the Battle of Killiecrankie in 1689. She then married William Livingstone (later Viscount Kilsyth) and, being Jacobites, they went into exile in the Low Countries. At Rotterdam, when the couple went up to say goodnight to their infant and the nurse, the turf roof caved in on them. Only Livingstone survived. He had the bodies of his wife and child embalmed and brought back to Kilsyth. In 1795 the vault was accidentally opened by Glasgow students and the bodies were seen to be in a state of perfect preservation. In 1989 a more official investigation had another look (almost 300 years on) and found the same thing. Mother and child looked as if just interred.

The ultimate in mausoleums has to be an edifice called the Craigentinny Marbles: 'a huge segmental pedimented Roman mausoleum shocking the prim houses surrounding it'—suburban bungalows off Edinburgh's Portobello Road.[9] Miller of Craigentinny had been an MP, son of a wealthy merchant (who only married when 91) but also something of a recluse, whose characteristics led to his sexuality being questioned (was

'he' a 'she'?). Whatever, he saw to it that his body rested twenty feet down and the monument soared twice that upwards. The result is certainly striking. There are finely carved marble panels on the sides, one showing Pharaoh coming to grief in the Red Sea, the other the 'Song of Moses and Miriam', the work of an eminent sculptor, Alfred Gatley. How times change; there is nothing enigmatic in a large stone half a mile from there which I saw recently which boldly commemorated male 'partners'.

The nobility all had coats of arms which served various purposes (including recognition by a largely illiterate population; if you saw the Campbell war galley waving on a flag you wisely did

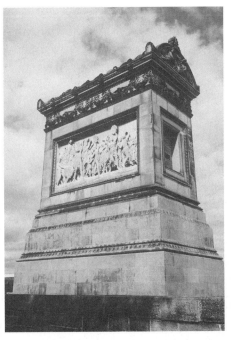

14. *The Craigentinny Marbles.*

a vanishing trick) and these were often displayed on their graves. The system went into decline when commerce became the real power in the land through the eighteenth century, and in Victorian times when all sorts were ennobled—and just think of today! The more anachronistic the more precious of course. Too big—and complex—a subject for this book. On the wall of Greyfriars Church there is an unusual crest with two kilted Highlanders as supporters (*fig. 15*). The motto *Loch Sloy* indicates they belonged to the parcel of rogues called Macfarlane. At Burntisland there's a magnificent merchant's stone with the fancy symbolic 4 and a fine coat of arms, someone obviously upwardly mobile if not securely arrived (*fig. 16*, the 4 is in the ₄ form, see p. 114).

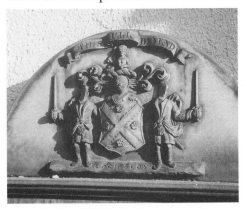

15. *Heraldic supporters wearing the kilt.*

Suicides were forbidden burial in graveyards, though local sympathies sometimes got round the rule. At Nether St Cyrus, on the right, just over the entrance stile, is a grave surrounded by a defensive railing which is for a local lawyer, George Beattie, who committed suicide (in the early nineteenth century) because he had been jilted. An extremely popular, lively character, the heart of any social gathering, his friends thought so highly of him they erected the memorial stone near the spot in the old graveyard where he blew his brains out (*fig. 34*).

A monument in graveyard or cemetery does not necessarily mark the burial spot. Forfar's cemetery is dominated by a huge monument—to Sir Robert Peel in gratitude for his repealing the Corn Laws. In Edinburgh's Dean the delicate figure of a crouching child commemorates a Lt. Colonel who died in Madras. In Scone there's a monument to local lad David Douglas who became a great botanical collector, particularly in the American North West. California poppies, lupins, evening primrose, flowering currant and *Garrya elliptica* were some of his introductions. Having survived shootings, rapids, facing grizzlies, Indian arrows, falling in love with a Chinook princess, often starving and desperate, he was finally gored to death by a bull in Hawaii when he fell into a bull pit trap. He was 35. Heroes and the famous are often commemorated in this way.

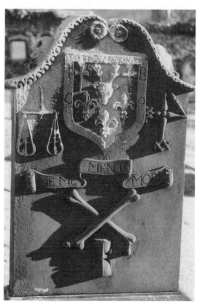

This world is a citie
Ful of streets,
And Death ye mercat
That al men meets.
If lyfe were a thing
That monie could
Buy, the puir could
Not live, and ye rich
Wold not die.
 (Elgin)[10]

16. A superior merchant's stone at Burntisland.

The Lore of Lairs

17. A clearly designated lair in Polmont Old.

AT Muiravonside's modern graveyard a big notice on the grass verge tells visitors DO NOT DRIVE ON THE LAIRS. The word lair might conjure up the abode of some ferocious animal, but in this instance it just means the resting place or plot of someone or some family and the derivation of the word is quite different.

Lair on early stones meant 'layer', just as *breids* (and variants *breeds, breds* etc) indicated 'breadths', in other words the dimensions claimed. The meaning changed, however, and 'two lairs' or 'two rooms' could then equally mean space for two, undefined. A double-width grave-stone (Willsher: 'double bedder') might claim 'two lairs' for instance. (At Kirkcaldy Old there are three in a bed! *fig. 18*). As the depth did not really matter, the word lair gradually seems to have come simply to mean the plot. Milnathort Orwell has many stones of this vintage, a lair of lairs. At Dollar a stone bears the words *This stone keeps to the dyke* (has

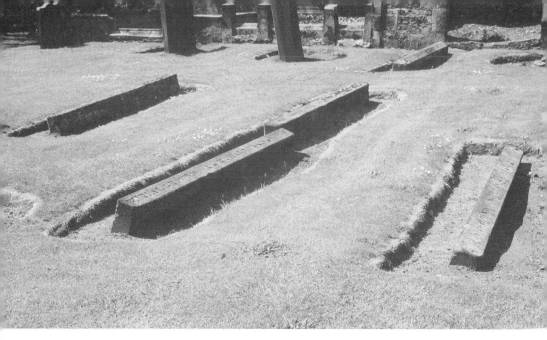

18. Triple widths in Kirkcaldy Old.

the space as far as the wall; ten feet away), at Cleish a faded *keeps three breeds* might have readers imagining some experimental farming.

In Victorian times a more verbal asserting of rights was made and you would read, for instance, *The Burrying Ground of James Tough (1838)* (Kirkcaldy Old), and variants on that wording. Perhaps this change led to the word *lair* finally just meaning the plot, as is inferred in the Muiravonside admonition. I'm glad the word hasn't completely disappeared.

Families were, and are, of course, protective of a family grave site, which is fine as long as care and attention are given to the plot but, with the passing of years, more and more plots with their gravestone(s) are forgotten, unless some keen American comes ancestor-hunting, and neglect can lead to decay and loss, sometimes of stones of aesthetic or historical value. But, perforce, all *belong* and may not be interfered with. Many of course are; but we will come back to this at the end.

The inscribed claiming of lairs disappeared as the stones themselves were made more attractive. On the whole, until Victorian times, stones tended to be of a modest size; anything more grand tended to be mural. In some places (south west Scotland especially) the Victorians went way OTT with huge stones of no artistic merit at all, creating a cramped and gloomy atmosphere, but such collections are, fortunately, rare, a local contagion. In contrast, Glasgow Necropolis, its swanky monuments well spaced over a hill-top with great views, has a distinctly festive atmosphere, weird enough to be wonderful (*fig. 40*). We will

never see the like again, of course, for Glasgow's Western Necropolis in Maryhill produced an innovation in 1895—a crematorium—and now most people are cremated, not buried, a disappointing necessity if one is interested in gravestones rather than a name in a book or a small plaque on a wall.

Many eighteenth century stones just had the two sets of initials of husband and wife – *1728 IF MM* at Stirling Old for instance (a heart between the initials) – or the two names are given. Others made their possession clear with wording such as *This is the burying place of James Love and Jean Goldie his spouse and their children* (Old Kilpatrick 1701). A stone in Perth Greyfriars simply has *In memory of his relations* and one in Kirkcaldy Old has the couple named—and adds *Former Generations.* In Glenesk, on the other hand, a triangular monument tops the Hill of Rowan (*fig. 19*); erected by the Earl of Dalhousie in 1866, it declaims *In memory of 7 members of his family already dead, and of himself and two others when it shall please God to call them hence.* That's fairly comprehensive.

Horizontal iron rails sometimes demarcated plots, but these have fared as badly as cast iron 'stones' (popular at Tobermory, Mull) and such usually lie rusted and wrecked. Admiral of the Fleet James Hope (C. in C. China during the Opium Wars) had his plot more efficiently marked off by using heavy anchor chain from a warship. (At Carriden, near Bo'ness.)

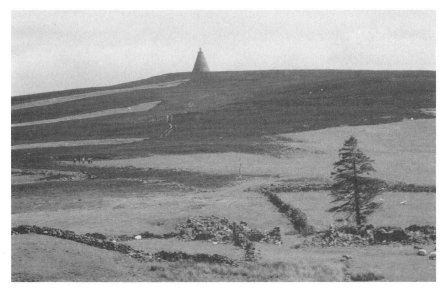

19. Hill of Rowan.

The Stone of the Stones

ℬℭ

20. Aberdour Church.

THERE has always been what could euphemistically be called recycling of stones. The rural ruin of Culross West has reused older stones as door lintels, one showing a Celtic cross, another a long sword, both now faded to mere tracings. In many cases the improvement-mad Victorians simply swept away old graveyards, and one mourns the loss of unknown treasures. At Eyemouth a watch house/shelter was built of older gravestones when these were cleared (see below); at Portmoak (Kinross-shire) a path is edged with stones; at Cults (Pitlessie) the belfry is made from the legs of table stones; at Caputh, Murroes and elsewhere stones were used to wall off the kirkyard. If you look at Aberdour Church across the graveyard the building seems out of proportion, with a huge roof crushing down on low walls (*fig. 20*). But as steps *down* to enter the church show, the walls are normal, it is the ground that has been built up. When space ran out in the graveyard, soil was carted in (literally) and burials could

then continue. Some stones removed at the time line the path to the church. They did the same at Eyemouth.

Not uncommonly the word 'Revised' may appear on a stone, indicating its reuse. I first met this at Alloa Greenside where a stone with *I M 1675* has had *D Buchan 1842* added, and there are several in Perth Greyfriars, one a piece of notorious vandalism, not untypical.

In the shelter at Greyfriars stands the 'Faith, Hope & Charity' stone, one of the most precious in Scotland (a notice describes its abundant primitive symbolism) which dates to the 1650s. We are lucky to have the date, for some vain person in 1828 carved out a section to insert his 'revision', and this has deleted the original person's surname and whatever else was inscribed. At the top of the stone, not damaging anything, are the words 'Renewed by John and Robert Pratt, 1861'. Was it only then we really began to realise the value of older gravestones?

The worst loss perhaps is the weathering of stones. This has been accentuated in the last decades, for I can compare pictures of stones I've photographed forty years apart and the comparison is depressing. Some modern practices don't help, the worst being cutting back the grass from around stones, which may make for easier mowing but allows rapid erosion to lay bare the often feeble brick foundations. Stones then become unstable and an all too easy target for vandals.

That so many of the earliest stones were flat on the ground has meant they have suffered worst of all from natural (and sometimes) unnatural weathering. That they were then given legs indicates the problem was soon noticed. Sadly, it took longer for the major defect to show; the actual stone itself, i.e. the type of stone used, was almost always sandstone and a local sandstone was often the worst of choices. While very variable, much sandstone is soft, easy to inscribe, but wears away all too easily. Even brief explorations will find stones with the lettering erased by weather, the stone badly pitted or sometimes with holes worn right through. (Kirkcaldy Old has one of the last.) Some forms of sandstone split along the planes and flake off the lettering, or even simply slice a stone into a 'book' of thin leaves. At Stirling Holy Rude a tree has produced such laminating with unintentional skill (*fig. 21*).

The strangest bit of damage I've seen was in Old Kilpatrick, where the groundsman drew my attention to an area where the stones had bits missing or had been stuck together again, and there was a lot of pitting; this, he explained, was the result of enemy machine guns during the awful Clydebank blitz in World War Two.

21. Tree splits stone; Stirling Holy Rude.

Today's damage is mostly caused by crass vandalism: yobbos, sometimes high on drink or drugs, who find knocking over gravestones is fun. Edinburgh Council went in for official vandalism too: in cemeteries and graveyards where stones were potentially dangerous *they* simply knocked them down, an appalling act, leaving many sites with masses of flattened stones, both unsightly and a heartbreak for the victimised families. And, whatever one feels about him, John Knox was one of Scotland's most important historical figures, yet he lies under the tarmac of a parking lot in Parliament Square. Money saved by neglecting graveyards probably is then spent on remedial work for the crime, drugs etc, resulting from such sites' misuse—but then, linked-up thinking is rather an alien concept in governments.

The bane of reading or photographing older stones (assuming some sunshine) is the accumulated ivy, moss and, above all, lichens that may envelop them (*fig. 22*). When I once did a gravestones slide show for the Scottish Wildlife Trust the person giving the vote of thanks made the humorous comment that it was the first slide show they'd ever had that included no wildlife content. Did they not see the lichens? An expert lichenologist might make something of lichens, but the rest of us can only wonder at the range of shapes, textures and colours of these neglected species, even if struggling to read what is under their grip. And, incidentally, graveyards are quite often very good places for observing wildlife; I've put up roe deer, fox, rabbit and stoat, and I once felt the wind from the wings of a startled buzzard on my face, having come round a corner onto the bird perched on a stone.

The Victorians, who could no doubt afford it more, took to granite, which certainly stands weathering, but the stone is very hard and not the most popular with masons, nor does the writing show up clearly

in many cases. *En masse* it is a bit overpowering.

In some graveyards it was popular for an iron bar to be affixed to the back of stones as a prop, but iron rusts away as the use of cast iron for the gravestones themselves soon showed. Very few cast iron gravestones are legible today; even if the frame has survived, the wording on the surface is usually blank. Sometimes ironwork was used in conjunction with stone, often framing a stone, or with a finial urn, and quite often for railings or other borders to the family plot. Larbert Old has a rare obelisk made of iron and I only know of one cast iron table stone (*fig. 23*) in Kirkcaldy Old. Cast iron stones seemed to be a passing fancy and

22. *Smothering ivy in Edinburgh Dean.*

certain areas of certain graveyards will have a smattering of them, as at Dunblane Cathedral or Stirling. At Rossie Island (Montrose) the iron was extraordinarily thin, which I've not seen elsewhere.

The Victorians loved marble, of course, and some of it has suffered from the acids in our atmosphere, the lustrous white turned to a sad grey. The best stone for standing up to stress is slate yet, apart from areas where it was quarried, slate was never popular. Odd stones of slate do occur country-wide, but that is all. The most accessible graveyard almost entirely using slate is at Ballachulish, the roadside church on the left as one heads towards the bridge from Glencoe. Stop next time. The stones have a similarity of design which points to a busy mason or copycat masons following and the carving is shallow, not deeply incised, yet looks as if done yesterday. The appearance is almost of someone playing with chalk on a greyboard, rather than a blackboard (*fig. 24*). At Strathmiglo (Fife) there is a propped-up slate off a roof which has been used as a gravestone! At Cill Chroisd in Skye I met my only example of a concrete gravestone (not weathering well). At West Wemyss (Fife) there was, till recently, a gravestone made of parrot coal and, here and

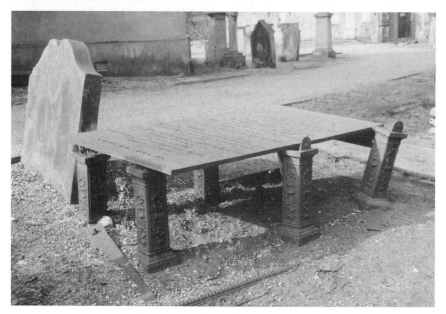

23. Unusual cast iron stones: an ornate cross at Stirling Holy Rude (top left), an obelisk at Larbert Old (top right) and a table stone at Kirkcaldy Old (below).

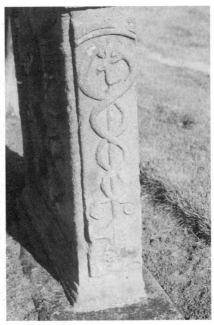

24. *Ballachulish slate, most impervious of stone.*

25. *The caduceus on the edge of a stone at Peebles.*

there, one may spot what looks like a marble stone only to discover it to be a stone painted white.

Be sure to look at all sides of a stone. Frequently the east-facing side will have the wording while the artistic representations are *on the back*. Look too at the narrow sides of old stones. Muiravonside has several odd figures, Peebles the only caduceus I've seen (*fig. 25*).[11] And because the pretty patterning on the side of a stone at Kinnair caught my eye I then discovered the wall-facing Father Time drama on the back. The legs of table stones are easily overlooked too. The top may have wording with a skull or head at each corner. In several Leith sites many stones have cherub heads with small wings instead of ears – rare, but I've noted Monimail (North Fife) and Athelstaneford (East Lothian).

The Writing on the Stones

ℬℛ

ONE thing that always catches my eye is the forming of the words, the lettering, the script itself. Most is quite unremarkable, which makes for a pleasant surprise when one comes on a stone where the 'roman' lettering or flowing true script is beautifully done. Art students from Dundee are taken round graveyards to observe lettering. I wonder if they have been over to Vicarsford in north east Fife. A stone there is inscribed in good lettering, as well it should, I suppose: *Rozelle Morrocco Artist 1926-2002 Beloved wife of Valentino and mother of Nicholas and Jack Morrocco. Valentino Morrocco. Architect. 1926-20.* The ending rather puzzled me, till it dawned on me that the stone had been created by the surviving artistic partner and still awaited his own departure for completion. It was not a mistake like *April 31*[st] appearing on a stone (*fig. 26*)[12] or, down the coast from Montrose, overlooking the Elephant Rock, where a small graveyard stone shows *George Ramsay. Born 1859. Died 1840.*[13] Morrocco found one way of ensuring a uniformity of lettering at least. You often see stones where all kinds of lettering is added to what is already in place. One at Kells (Kirkcudbrightshire) made me smile for, like someone misjudging their writing a postcard, the lettering becomes smaller and smaller all down the crowded face of the stone. The key to pleasing is often in simplicity, in not overloading the stone with words. In the Dean (Edinburgh) the 1995 Basil Skinner stone exemplifies this (*fig. 27*).

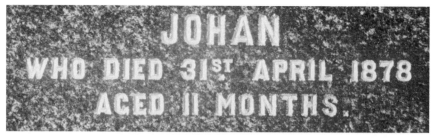

26. Johan's surprising date of death (West Wemyss; there's a similar error at Sanquhar).

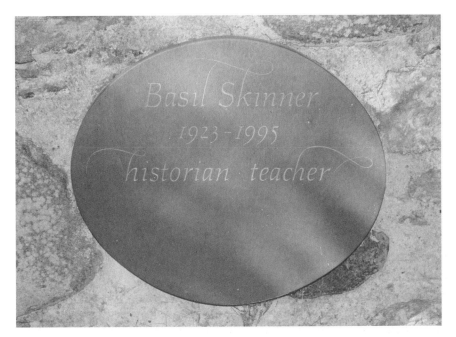

27. Style with simplicity.

In East Wemyss there's a 1905 stone designed by Rennie Macintosh which has the wording very much in his style, perfectly pleasing, but the description of the stone as 'outstanding for its inventive sinuous beauty' (as an architectural guide proclaimed) has made many an audience laugh. 'Awkward' would be the kindest word, even if it is by Rennie Mackintosh.[14]

Script, in the sense of what looks like copperplate writing rather than printing, is rarer and harder to pull off. The biggest spread of such I've found is at Carmyllie (Angus), a sort of rhyming declaration of 'East west, hame's best':

Let marble monuments record their fame who distant lands
 explore,
This humble stone points out the place where sleeps a virtuous
 ancient race.
Their sire possessed ye neighbouring plain before Columbus crossed
 the main
And tho ye world may deem it strange, his sons, contented, seek no
 change,
Convinced wherever man may roam, he travels only to the tomb.

One item from an under-taker's pattern book riles me because I loved the original as a boy and meet it today everywhere, but everywhere: Dürer's 'Praying Hands'.[15] The original engraving now appears in every medium, in colour, frequently reversed and crudely overused. (I've a slide in which three appear in the one view.) So, straying to the modern end of Peebles' graveyard, I was surprised and pleased to see it used sensitively in combination with a good script; modern can be stylish (*fig. 28*).

28. *An attractive use of Dür-er's 'Praying Hands'.*

The wording on old stones can also intrigue, as I know from the reaction when I show slides of some of the odd quirks on them, how words are split randomly at the end of lines, how they change from upper to lower case, insert letters, correct spelling mistakes and, anyway, have the different spelling or phrasing of their own day. Just look at these examples! (*figs. 29*)

29. *Some stones can be fun to make out; examples from Barr (left) and Torryburn (centre and right).*

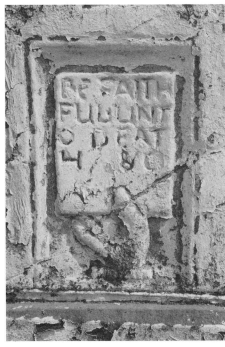

30. The easy made difficult.

The most ridiculous one I've seen is on a Covenanter's stone (1685) at Barr in Ayrshire. There are four garbled lines: *Be faith / ful unt / o deat / h* which was making rather a mess of the straightforward: *Be / Faithful / Unto / Death* (*fig. 30*). In those days the mason could well have been illiterate and/or copying what he was shown.

Here lyes starting an inscription is not a spelling mistake but just how the word was spelt then – and a useful indicator for dating. An old style s can look like an **f** to us. Interpreting the old-style writing is still a game worth playing.

The habit of splitting a word just as it happens at the end of a line may amuse but can sometimes momentarily confuse. There's a stone in the old Kilmore graveyard above Dervaig (Mull) which (too difficult to photograph) rather jolts as one reads down:

> *In memory of*
> *Catherine Campbell*
> *spouse to All*

In order not to give away the explanation, note 16 shows what is happening.

Another surprisingly frequent mistake is having a letter missed out, so the stray is quite casually inserted above where it should be. This is also done if there is only the last letter of a word missing at the end of a line. The less educated mason also sometimes had difficulty with individual letters, the most often being N reversed as Ͷ, or S as ꙅ or D as ꓷ. At Dalgarnock (Stewartry) a 1750 stone manages to have woh for who and gets the figure 4 upside down: ⇁. Finding examples of these is always fun.

In Kilmuir, Skye, there's this inscription: *Here lye the remains of*

31. Two stones at Clackmannan, surely the work of one hand (left). Stones at Kirkliston and Dalmeny (right) also suggest the work of the same mason.

Charles MacKarter whose fame as an honest man and remarkable piper will survive this generation for his manners were easy and regular as his music and the the melody of his fingers will. The wording was never completed, the story being that the commissioning son was drowned while ferrying cattle across the Minch, so the mason – unlikely to be paid – left. (Or he departed when he saw the error – *the the* – he'd made!)

Often, wandering round an old kirkyard, many stones have a strikingly similar appearance and would very likely be the work of a particular mason. Good examples are at Canonbie, Kinnoull (Perth), Peebles, Norham (E. Lothian), Kirkmichael (Ayrshire), Kilsyth (NE of Glasgow) and Tayport (NE Fife).

There's something of a new (or old) language to be explored in our graveyards. A stone might have, say, '*In memory of Agnes Honeycombe relict of William McMicking…*' What could be more Scottish than *relict*, though *spouse* has a ring to it too? Old trade names like *flesher, cordiner, baxter* are a delight. (An *officer of exice* might be less welcome.) Some stones may have that word *Revised* on them (see p. 17) which indicates an older stone is being re-used and, of course, there's all the business of *lairs* and *breids*. A stone at Lanark remembers all *Rechabites* who fell

in World War One; these were members of a body who observed complete abstinence from alcohol.

One notable feature in *Scottish* graveyards appears in the last paragraph: Agnes Honeycombe is relict of William McMicking, not Agnes McMicking *nee* Honeycombe or any other variant. A wife traditionally was always given her maiden name. (If a modern stone doesn't, this just indicates a surprising ignorance.) You can imagine how useful that feature is for people tracing ancestry. For this reason, names and inscriptions, which I barely mention, are vital in any proper survey of a graveyard and have the priority in recording.

Collecting *odd* names can be a good graveyard game. Have you met any of these *Macs*: McIllwee, MacKellaig, McOuat, McLuckie, McCaa or McAughtie? I seemed to have met a barrage of odd names with H: Haddock, Hurry, Hush, Heart, Hatch, Higgie, High, Hiddles, Heugh, Hadaway... and what of Scorgie, Spankie, Snowball, Plank, Fish, Mustard, Eyes, Tittle, Baldy, Foggie, Hovelshroud and Deadman?[17]

Languages? English, French and German appear on a single stone at East Wemyss, other languages (as I've first noted) have been Latin (Edinburgh Greyfriars), Gaelic (Kildonnan, Eigg), Dutch (Burntisland Old), Polish (Perth Wellshill), Russian (Faslane), Chinese (Edinburgh Liberton), Turkish (Portobello), while Hebrew and Arabic are on stones in Jewish or Muslim cemeteries.[18] (Additions welcome!)

A Word in Place

ဆာၰ

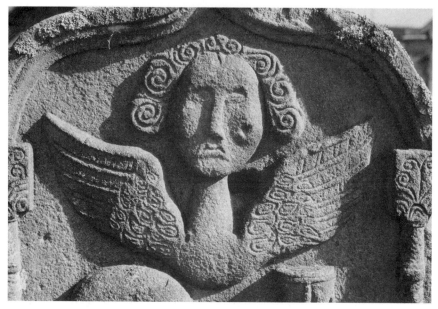

32. No smile despite the hair-do (Peebles).

Let's talk of graves, of worms, and epitaphs.
(Shakespeare, *Richard II*)

Too often I've ignored epitaphs on site in the rush to take photographs. Copying the words takes time! However, there are whole books given over to the topic of epitaphs but, be warned, interesting epitaphs quoted in Victorian tomes can't always be found on site today, and surveyors noting inscriptions often sin in my eyes by only noting words and not the folk art element.[19]

In my local graveyard (Burntisland) there's the following version of a regularly expressed sentiment: *Read here as you pass by, / Look on this grave wherin I lie; / From cares and troubles I'm set free; / Mourn for yourselves, but not for me.* West Linton has *Some hearty friends may drop a tear / On our dry bones, and say, / These once were whole as mine appear*

/ And mine must be as they. Broughton is more severe: *Man's life is ever on the wing / And death is ever nigh, / The moment when our lives begin / We all begin to die.* And some raise a smile: *Stranger as you pass o'er this grass; / Think seriously, with no humdrumming, / Prepare for death, for judgements coming.* (Glasgow Necropolis.)

There seem to be any number of odd fatal accidents (see the section on the topic as well). In Cullen there was: *Malcolm Downie, / Lost his life ae market nicht / By fa'in aff his pownie.* Or a Lochyside chiel who was attacked by a *grey bull, – He being sore offended / I from ma horse was forced to fa' / And so my days were ended.* A Jedburgh mishap: *Stop, traveller, as you go by / I once had life and breath / But falling from a steeple high / Swiftly passed through death.* Others with mention of a trade are not uncommon. A Fife one: *I bore goodwill to every creature / I brewed good ale and sold it too / And unto each I gave his due.* My favourite, at Kinnoul, Perth: *Halt for a moment / Passenger & read / Here Andrew dozes / In his daisy bed / Silent his flute / And torn the key / His pencils scattered / And the muse set free.*[20]

Some don't sound too confident about the future: *Like crowded forest trees we stand / And some are marked to fall / The axe shall strike at God's command / And so shall smite us all.* (Glen Prosen)

There's nothing like laying it on: *Time flies, Death urges, Heaven invites, Hell threatens / Believe, repent, prepare for Death, for Judgement...* (Dun) or, brutally brief, *Memento Mori* in spades: *Thou mayst be the nixt that dies* (Dollar).

How lov'd, how value'd, once avails thee not / To whom related or by whom begot / A heap of dust alone remains of thee / Tis all thou art and all the proud shall be. (Barr)[21] Campbeltown has a similarly democratic ring: *This little plot is all I've got / And all that kings aquire...*

Some obviously prepared well, like the following at Kirkcaldy Old:

> *James Baxter, Wright, his wyfe here lyes!*
> *Grave Janet Baxter, Meeke and wyse;*
> *James Baxter Wryght, her[e] leaid beside hys wyfe*
> *Ye ninth of March departed from this lyfe,*
> *He made their coffins baith now laid in clay,*
> *Oh mortal man for James and Janet pray.*[22]

Some odd attributes are noted: *Here lies the dust of Robert Small / Who, when in life, was thick not tall...* (Newtyle). *Here lies John Smith, / Whom death slew for all his pith, / The starketh man in Aberlady – / God prepare and make us ready.*

Here lies – maybe – for sometimes stones would be erected long after an interment, as the family had to save the considerable cost: *In this churchyard lies Eppie Coutts / Either here or hereabouts, / But whaur it is none can tell, / Till Eppie rise and tell hersel'.* (Torryburn according to Rogers, but I can't find.) At Potterhill, Paisley: *Here lies Mary, the wife of John Ford, / We hope her soul is gone to the Lord; / But if for Hell she has chang'd this life / She had better be there than be John Ford's wife.*[23]

If less memorable, triumphant faith is equally expressed: – *Time ripens mortals for the grave / And death soon cuts them down / But they that Jesus Christ receives / Shall have and wear a crown* (Kilspindie); *O may the grave become to me / The bed of peaceful rest / Thence I shall gladly rise at length / And mingle with the blest* (Kirkton of Balfour, Kincardineshire); *Life is uncertain – death is sure, / Sin made the wound, and Christ the cure* (Monifieth); *When in the last and awful day / The heav'ns and earth shall pass away / I than shall hear my Saviour say / 'Be not afraid for it is I'* (Forgan); *Life's race well run / Life's work well done / Life's crown well won* (Kirkcaldy Old).

Often a triumphant verse from Scripture appears instead, and I've listed some on p. 98. A gentle favourite: *Friend do not careless on thy road / Overlook this humble shrine / For if thou art a Friend of God / Here lies a friend of thine* (Leslie, Kirk on the Green).

Humour can alleviate pain, as some inscriptions no doubt intended. There can be puns too, visual puns like the *bells* and *gloves* portrayed on the eighteenth century Bell and Glover family stones at Crowdie-knowe. At Peebles, more recently, the Howlett family have owls shown on their stone; at Moffat, Annie Swan has a swan. I've seen a Mr Irons – blacksmith; a Mr Hay – farmer; Mr Tawse – schoolteacher.[24] This is nothing new; Perth Greyfriars has this play on the name of Mr Conqueror, a town bailie who died in 1653: *Oer death a conqueror heir lyes / whose soul freed from the dust / triumphs oer the pole...*

In St Andrews there's a stone in memory of someone *who fell off the Step Rock / Into the arms of Jesus.* These double-entendres are not uncommon – like the stone erected by a widow with the *RIP* (Rest in Peace) followed by the unfortunate *Till I Come* or the Rev Thomas Young, noted as *Father of all the Parish.*

> *Erected to the memory of*
> *John McFarlane*
> *Drown'd in the Water of Leith*
> *By a few affectionate friends.*

She lived with her husband / of fifty years and died in the / confident hope of a better life.

> *Erected in respect of David Dawson*
> *By fellow members of the Milton Rifle Club*
> *Honorary president for eighteen years*
> *'Always missed'.*

I'll save for later some of the rhymes (mercifully short) which have spread like an epidemic on today's gravestones.

> *Farewell, vain world! I know enough of thee,*
> *I value not what thou can'st say of me.*[25]

There's an enigmatic stone at Peebles that just says *Lucy 1935*, then adds *She has done what she could*. At Milnathort Orwell there is a woman promising *I shall obey*, and what do we make of *To follow thee I'd be content / Did I know whereto thou went*, or *Gone but not in the gone sense* (Arisaig) or *A man is best known when he is dead* (Liberton)?

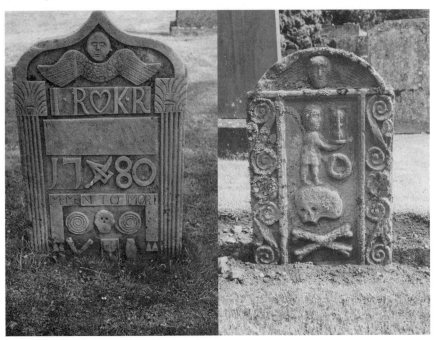

33. Spittal of Glenshee, left; Barr, right – fine eighteenth-century work.

Resurrectionists

෨☙

Here lies nothing.
The impious Resurrectionists
At night dared to invade
This quiet spot, and upon it
Successful inroads made.
And when to relatives the fact
Distinctly did appear
The stone was placed to tell the world
There's nothing resting here.
(The Howff, Dundee)[26]

IN 1505 a law was passed and anatomists were allowed one cadaver a year. In 1694 vagrants, suicides, those executed or who died in 'houses of correction' were also made available, but, with the explosive new knowledge of the Enlightenment and the growing interest in medicine, this was a completely inadequate state of affairs which government, with typical British procrastination, did nothing to alleviate until Acts were passed in 1832 and 1871. Students, desperate for anatomical training, took the easy option and secretly dug up newly buried bodies; and their mentors were not going to ask awkward questions, were they? Moreover, the fact that bodies would actually be paid for soon had the professionals moving in. Gangs of grave-raiders became a notorious part of the social scene, hated by the populace in general and any bereaved family in particular. There were frequent riots and near-lynchings. Street children in Edinburgh chanted, *Up the close an doon the stair, / But an ben wi Burke and Hare. / Burke's the butcher, Hare's the thief, / Knox the boy that buys the beef.*

To be accurate, Burke and Hare were not Resurrectionists, they were worse, hence their notoriety. When someone died in their lodging house, they opportunistically took the body to the anatomists and received £4 (£400 today); and thereafter decided to murder people for such good money. Dr Knox was happy to pay for such fresh, clean

material. Between 15 and 17 people are thought to have been killed by the pair before they were discovered. Hare turned king's evidence but Burke was hanged, 20,000 watching the event (1827). By a nice irony Burke's body went to the anatomists and his skeleton today is in the collection of Edinburgh University. His skin was tanned and pieces sold off as souvenirs.

Both had worked on the cutting of the Union Canal, and canals were useful for smuggling in bodies from nearby rural graveyards. Grave robbery was by no means an Edinburgh monopoly (there were riots in Aberdeen and Glasgow). The usefulness of the Forth & Clyde Canal saw the church at Cadder (near present Bishopbriggs) erect a watchhouse, and there's a surviving mortsafe on site.

Steps were taken to safeguard graves, which might mean a conscientious family standing watch for several weeks, but that was not always practical. Many burial grounds were walled round and had watchhouses built where family or paid observers could be stationed at night. This safeguard, of course, was open to abuse as watchers could be bribed, were inefficient, often drunk or feebly inadequate for tackling a dangerous gang. However, spotting watchhouses is one of the games which can be played by visitors to kirkyards: they will have window(s) facing the graves and often a chimney (which will sometimes distinguish them from almshouses, hearsehouses and session houses, etc). Cadder's is a gem (*fig. 34*) and some others I've noted: Seaside Nether St Cyrus (*fig.* 34), Eckford (a round tower), Loch Leven (Kinross), Banchory-Devenick (outside Aberdeen) octagonal Baldernock, grandiose Calton New and St Cuthberts (*fig.* 34) in Edinburgh, this last the obvious pavement-side tower as one heads along Lothian Road from the West End. I doubt if one passer-by in a thousand recognises the battlemented tower for what it is.

There's a tale of two old codgers in a watchhouse hearing movements one dark night and being too afraid to investigate. A blast from their blunderbuss however led to silence. Cannily waiting till morning light to investigate, they crept across the cemetery to see if they had hit anything. They had: the minister's cow.

Kirkintilloch Auld Aisle has a watchhouse room incorporated above the graveyard's arched entrance. In the graveyard there are examples of graves being protected by having high, spiked railings round the lair, overall the commonest defence. There's an example at Cadder. A more portable form of this is the mortsafe, a peculiarly Scottish effort, the best known site at Logierait, just west off the A9 at Ballinluig. These

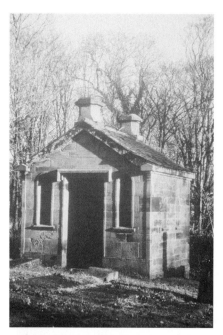
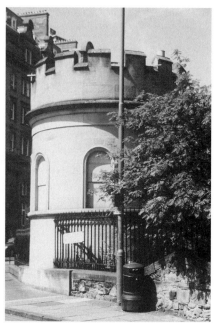

*34. Contrasting watch houses: Cadder (top left), St Cuthbert's,
Edinburgh (top right), Nether St Cyrus (below).*[27]

are coffin-shaped covers like wrought-iron cages and there are two big and one child's lying together in this graveyard (*fig 35*). The Episcopal church of St Ninian's in Glen Urquhart has a rarer Highland example. A more common defence was to use a plate-iron box which could then be locked against robbery – and was reusable. These were usually hired out, a nice sideline. There are two in the old church ruin at Alloway, one at Colinton (Edinburgh), Cadder, and one at Airth which took some finding among the brambles.[28] Another not quite identical, with the same 'Airth, 1832' on it, is on display in the Royal Museum of Scotland (Edinburgh) which has an interesting display on our subject. Many mortsafes known to exist once were carried off as scrap during World War Two and others suffered recycling – as a water trough for cows in one case.

At St Michael's, Linlithgow, there's a heavy coffin-shaped cover (some open work) which would simply sit on top of a coffin and deny easy access over the weeks before a body would be decayed enough not to interest anatomists. At Kinghorn there is a solid full size coffin-shaped mort stone with a ring on top which could be lowered on top of a coffin with the same effect.[29] I'd like to know of others. One Fife graveyard used a mort collar: a chain bolted through the bottom of

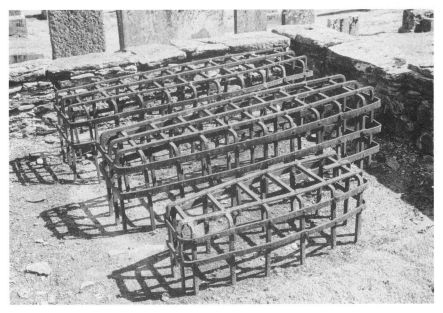

35. Logierait mortsafes.

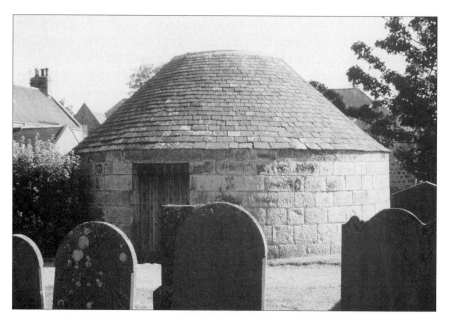

36. The unique round mort house at Udny, Aberdeenshire.

the coffin and fastened round the neck of the corpse,[30] and a large iron clasp also served the same purpose.

There were also morthouses, where coffins were locked inside till *nought remains but shanks and skulls* (Dunfermline), anything up to six weeks. Crail, has one, ('*Erected for securing the dead*' on the 1826 inscription above the door), but I'm surprised there are not more for such a simple solution. At Udny (Aberdeenshire) the building was made round in shape (*fig. 36*) and contained a carousel which would move on day by day, completing a circuit in 2-3 weeks. It was built just in time to be rendered obsolete by the overdue legislation that gave the medical profession greater access to corpses.

One person not likely to be disturbed was John Hunter, a cabinet-maker in Kirkcaldy who bought a mansion from the provost and bequeathed it as a hospital to the town. Now it is a residential old folk's home. His canopied bust still stands before the building (best seen from the rooftop Tesco car park opposite) with himself buried below – in an upright position. Ann Watters mentioned that some burials in East Wemyss cemetery were made feet down to save space.

A different resurrection story concerns the brothers Ebenezer and Ralph Erskine, who were to be leaders in forming the eighteenth century Secession Free Church. Their father was a minister in the Borders.

His wife died (c.1680) in her thirties and was duly buried. While he was dispensing the usual hospitality once home from the funeral there was a knock at the door – and there, to everyone's shock, stood his shrouded wife. Grave robbers had dug up the coffin and, unable to take the ring from her finger, had cut off the digit. The sudden pain roused her from what must have been a cataleptic coma, and she somehow managed to return home. Ralph was born after this traumatic episode and was dedicated to the church. He lies in a large sarcophagus-style monument beside Dunfermline Abbey.

Grave robbers were detested, and when caught stood a very good chance of being lynched. Their trials were often the scene of riots in what were far from the peaceable times we imagine. Riots would attend another saga which has left its record on gravestones.

The grave of Andrew Wilson in Kirkcaldy Feuars was erected through popular public subscription. He was a Kirkcaldy-born smuggler, executed in 1736, which tells something of how the Excise was viewed. He and a companion, Robertson, had been caught, and after their trial in Edinburgh were taken to church. Wilson, by creating a scene, allowed his mate to escape (a scene witnessed by Adam Smith). When Wilson was hung at the Grassmarket the spectators grew so riotous that John Porteous, Captain of the Guard, ordered his men to fire on the crowd. Thirty were killed or wounded. Porteous himself was put on trial for murder and sentenced to death, but at the end had the sentence commuted, which so infuriated the mob they broke into the Tolbooth, dragged Porteous out and then hanged him from a dyer's pole in the Grassmarket. His grave in a dark corner of Greyfriars was only marked in 1973. (Not far off from the Porteous stone is that of William McGonagall, 'the world's worst poet'.)

Covenanters

ഉ)(രു

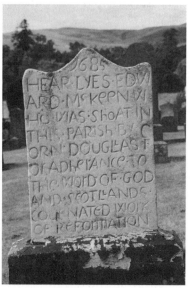

37. A Covenanter's stone at Barr where such have been painted white.

In the seventeenth century Scotland was bloodied through a fanatical, fundamentalist faith the equal of anything seen since. I'll try to give an unbiased historical summary. The Reformation left Scotland with a Presbyterian form of worship, a church government which, unsurprisingly, clashed with the practices of Charles I. When in 1637 he tried to force a Book of Common Prayer on the Scots the reaction was the drawing up of a National Covenant (1638),[31] which was signed by about 300,000 people. This put God as head of the church and not a king. The English opposition to Charles was glad to use Scots aid, but when Charles was beheaded in 1649 the Scots were appalled and Charles II was then crowned at Scone after signing the Covenant – which he would repudiate on his restoration. Cromwell and the Commonwealth also went back on promises, but in those days of political change religion was frequently the driving force.

At the Restoration Charles II revoked all Acts back as far as 1640 and forced episcopacy on Scotland. The firm Covenanters refused to comply (which was both a political and religious matter) and held services (Coventicles) of their own, often in lonely places in the country. They were defeated in several battles, and over the period till 1688, under Charles II and James II, something like 18,000 died in the persecutions, which became ferocious after the murder of Archbishop Sharp in 1679.[32] This became the 'Killing Times', when dragoons rode the hills under leaders like Claverhouse (Bloody Clavers or Bonnie Dundee according to loyalties). Some extremists even refused to acknowledge William and Mary after James II had fled. The profligate court of Charles II, and the king himself, could not but clash with the fanatically religious Covenanters, but the cruel and often indiscriminate persecution would mark the psyche of Scotland – to this day. English powers and religion were not to be trusted. Torture and the cold-blooded murder of men, women and children were common.

There's a huge (largely biased pro-Covenanters) literature and many sites are marked with memorials. Covenanters' gravestones and memorials are scattered throughout Lowland Scotland and southwards, with the biggest number in Ayrshire, Dumfries and Galloway, Lanarkshire and Fife. Some were buried where they fell on lonely hillsides miles from anywhere – like John Brown of Priesthill in the hills above Muirkirk.[33] He was a carrier/farmer and a charismatic preacher who would draw a large congregation on Sunday afternoons but, on absenting himself from the forced episcopal attendance, he was seized and shot, perhaps by Claverhouse himself, in front of his pregnant wife and children.

What they would call 'Providence' could often play its part. There are several Covenanters stones at Barr (easy to spot as once painted white), stones which tell stories. *Here lyes the corps of John Campbell who was banished from Wallwood to America for Chriss cause in [16]83 but by providence he returned in [16]85 and dyed August 1721 aged 79.* Alexander Burden on the other hand was banished as a slave, but was drowned when his ship, the *Crown*, foundered off Orkney (200 drowned in all). Edward McKeen was an innocent youth, who, seeing a troop of twenty-four riders approaching a farm where he'd simply come to buy corn, hid, was dragged out and shot several times in the head. The son of the farmer was spared at the last minute, but the experience left him mentally deranged for the rest of his life.

Alexander (Sandy) Peden was a renowned Covenanter preacher. He was captured and imprisoned with others on the Bass Rock, where sev-

eral died of privation or went mad. Peden was shipped off to slavery in Virginia, but the captain of the ship refused to carry the sixty 'enthusiasts' and set them free in London. Harried for years in the south west of Scotland Peden survived to die in his bed. He was buried at Auchinleck near the Boswell vault (James Boswell, biographer of Dr Johnson, would later be interred there) but this became known, and forty days later the soldiers dug up the corpse and took it to Cumnock, intending to hang it on a gallows. Several local nobles interceded, nevertheless 'Christian' burial was refused and Peden was buried at the foot of the gallows. His stone reads '*Here lies Mr Alexander Peden… who departed this life 26ᵗʰ January 1686, And was raised after six weeks out of the grauf and buried here, out of Contempt.* In the Museum of Scotland there's a rather frightening hairy mask he wore to avoid being recognised.

Often monuments were erected with a general commemoration of the Covenanters in mind, useful propaganda for zealous Victorians, or think of Scott's *Old Mortality*.[34] Edinburgh Greyfriars has a well-known mural monument (after all, many Covenanters were to be imprisoned, tortured and killed in the capital), Lanark has a big obelisk in the graveyard for its martyrs and Stirling has the huge Star Pyramid near the castle esplanade (*fig. 38*). There are many more.

Stirling also has a marble, canopied monument (the figures now headless) for the Solway martyrs (1685), as grim an act as any recalled.

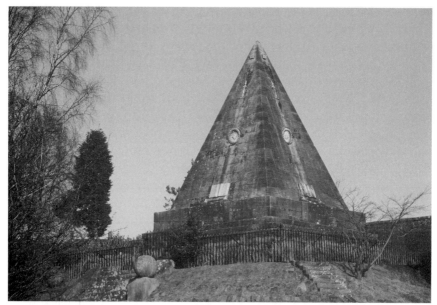

38. Stirling's Star Pyramid commemorating the Covenanters.

For sticking to their beliefs, two females, Margaret McLauchlan, in her late sixties, and Margaret Wilson, aged eighteen, were tied to stakes in the Solway Firth near Wigtown and left to drown in the incoming tide. The monument shows an angel watching over Margaret Wilson and her thirteen-year-old sister Agnes who is reading to her. Agnes had also been condemned to die, but was bought off by their father. The canopy was added later, but the sculpture was the work of Handyside Ritchie who was also responsible for the scattered monuments of reforming and covenanting divines throughout the Valley Cemetery, part of Stirling Old (some sadly damaged or overgrown): John Knox, Andrew Melville, Alexander Henderson, James Guthrie, James Rennie, Ebenezer Erskine. Five of these sculptures, the Martyrs' Monument and the Star Pyramid were all commissioned by a zealous Christian nurseryman, William Drummond. Trees from his nursery clothe the crag topped by the Wallace Monument.

The Enlightenment perhaps escaped from this trap of fanaticism, with some even challenging the existence of God, yet at the very end of the eighteenth century an Edinburgh student would be hanged for blasphemy. And who knows how any of us would have behaved if alive during those bloody decades. Another stone from Barr in the heart of Covenanting country can well end this section: *Infinite joy or endless wo / Attends on ev'ry breath / And yet how unconcern'd we go / Upon the brink of death.*[35]

Viva Victoria
ಬಿಂಬ

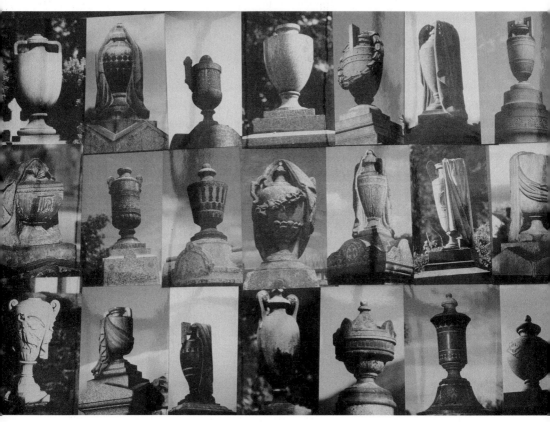

39. The ubiquitous urn; a challenge to any mason's originality and worth more than just a glance. Just why they were so popular is a matter of speculation.

A Victorian graveyard is probably the image that springs to mind when anyone thinks of a graveyard – with fairly negative enthusiasm; they are just so big, so overwhelming, so repetitive, and later cemeteries even worse with their serried ranks of the grey identical. While this is largely true, understanding something of the Victorians' ideas and how they are expressed can vastly improve wandering round such a site.

That such sites are so OTT is a reflection of the sheer ebullience of the period. Britain was 'great' and the Victorians showed it, living or dead. The population was exploding and more people could afford gravestones. The upwardly mobile wanted to be recognised – just like today. The accusation of sentimentality is one I grow largely to disbelieve – visit any cemetery in use today if you want to observe extreme sentimentality – and the moral aspect is probably no worse either. Many Victorians were devout believers, so would naturally erect monuments to the Covenanters (even in towns which had no Covenanting connection) or create grandiose marble monuments for the all too frequent deaths of children. A great deal of what is covered in Part One comes from and primarily concerns Victorian graveyards, the period best extended up to the full stop of World War One, when that dreadful event would change things utterly.

The first planned cemetery (as against graveyard) on a grand scale was Père Lachaise (Paris), founded in 1804, with a display outdoing Glasgow's Necropolis (1833). England's first like this was the Rosary, Norwich, in 1819. Mediterranean countries with catacombs, charnel houses and vast banks of family 'lairs' like large left-luggage cubicles are often astonishingly ornate and OTT to our British eyes. The Victorians often swept away older graveyards in their lusty developments. The parish church of St Andrews sits in the centre of town with paved areas and roads around it – but it once stood in a graveyard. Cemeteries, of course were more democratic and open to any denomination or even foreigners, an important factor as national denominations had offshoots from the seventeenth century onwards. Today my local town, Kirkcaldy, has nearly a score of different forms of worship, Christian and otherwise.

Empty areas in graveyards (well into the nineteenth century) sometimes point to unrecorded burials in times of fierce epidemics or plagues. Victims could even be interred in a communal grave. In Kirkintilloch some years ago, when the Orchard burial ground was dug up to create a relief road, five smallpox victims were sprayed and moved most carefully (by men in protective clothing) to a spot in the Auld Aisle. In those early days there was every reason to fear such killer infections, of course (see p. 66). Paupers were also interred in communal, unmarked graves (up to forty in one pit) and suicides were refused burial in consecrated ground.

Symbolism still meant a lot in Victorian times and they did tend to show it large. Some of the features that we take for granted as representing Victoriana can briefly be mentioned.

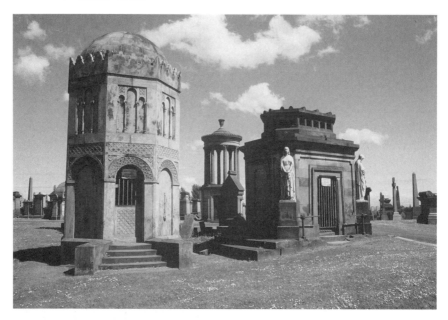

40. The rich extravagance of Glasgow's Necropolis.

Obelisks were popular, I'm sure, because of their visual impact, and probably had an origin in eastern influences – like the pillaging of Egypt's Cleopatra's Needle (*fig. 23 top r.*).

Truncated pillars no doubt had part of their inspiration from the classic remains observed on Cook's Tours, a fairly blunt symbolism.

Caskets/Sarcophaguses might suggest that there is a body held inside, but there never was. There are some imposing examples too in Edinburgh Greyfriars, that are much earlier than Victorian times. The small casket, as a finial on top of a stone or pillar, became typical Victoriana.

Urns were never the receptacle of ashes; crematoria being a more modern institution. I've not come on any plausible reason for the great popularity of urns or why many are draped or what, if any, symbolism is involved.

Crosses came back into fashion, having disappeared at the Reformation, when portraying Christ on the Cross was deemed iniquitous and had the effect of stopping *all* crosses. However the Victorian interest in things Celtic saw this style of cross become very popular, and there are any number of extremely fine examples: Edinburgh Corstorphine or the Dean, St Andrews, Glasgow Necropolis (*fig. 41*), but really everywhere. The figure of Christ on the Cross today will inevitably point to

a Roman Catholic interment, which will often be backed up by, say, an Italian, Polish or Irish name. Occasionally, as at Lanark, there will be a separate RC cemetery – which in this instance has a startlingly fine modern Calvary.

An Open Book has remained popular into modern times, the Victorian open pages in white marble and black wording being given a range of variants. The symbolism is obvious, though having one's name in the Book of Life[36] may not determine the choice today (*fig. 42*).

Doves were a popular Victorian symbol, often added on to a gravestone as a separate figure, the bird in almost any posture; but they were prone to damage and many indeed have disappeared. The dove will still appear today, but usually inscribed rather than sculpted.

Rusticated is the term used when stone is made to look like something else, almost always wood. One common version shows a tree with its trunk and branches lopped off, a fairly crude symbolism, another has the stone bordered/surrounded with the same effect. The result is unconvincing (watch children's reactions!) as is faking up a cairn of boulders, stone imitating stones.

Flowers and Fruit. These may be sculpted or finials,[37] but are most often an inscribed decoration; extremely common, sometimes very attractive, either as abstract representation or as perfectly recognisable

41. Celtic Revival cross in Glasgow's Necropolis.

42. A variant on the Open Book style at Dollar.

43. *Victoriana: an Immortelle at Kinfauns (top left), super-sentimentality, East Wemyss (top right) and a Perth Greyfriars' example of the 'Sair Heid' (below).*

species. Their tradition goes back long before the Victorians and continues into the present. One of the finest modern-looking thistle carvings I've seen is on an eighteenth-century stone at Girvan, and Tayport, in contrast, has a very dainty nineteenth-century thistle spray. There are pretty oak leaves at Auchtertool, a pineapple at Kirkcaldy Old... Palms, with their biblical references, had a symbolic importance which has gone today.

Glass domes (Immortelles), with or without protective iron grilles covering them, are an almost forgotten Victorian element, being far too fragile to survive – but survive some have, the precursors of today's delight in plastic flowers and figurines. (Try Collace, Cargill, Kinfauns (*fig. 43*), rural enough sites to have been spared the vandals.)

Sair Heids. This was the name I gave to one group of the Victorian sculpted figures which crops up here and there – Milnathort Orwell, Edinburgh Dean, Perth Greyfriars (*fig. 43*): a sorry draped figure leaning an elbow on a pillar or gravestone or whatever, with hand up to head. What a depressing choice for a loved one's grave!

Angels in white marble are often eye-catchers, as if out to rival Michaelangelo, though the odd one can be a striking success. Many

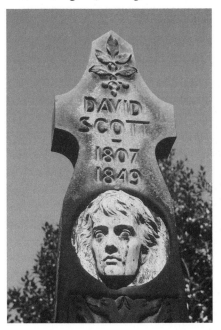

44. David Scott, one of Edinburgh Dean's striking medallions; tinker symbols on the grave of William Marshall who died aged 120 (Kirkcudbright).

are just repro from an undertaker's pattern book, some, usually for children, can be poignant, some can make you squirm – like *fig. 43* perhaps. Their symbolism of course hints that those commemorated are up in heaven along with God and his angels, which the inscription may or may not back up. Marble was used for a wide range of subject matter and presentation, friezes were popular, urns of course, sometimes busts or cameos portraying the interred. The stone often becomes pitted or dirty-looking from air pollution.

Medallions of Victorian gentlemen (have you seen any for a lady?) were often fine works of art. Bronze was the most favoured medium, though some appear in copper which takes on a pleasant green patina. City locations; like the prolific range in Edinburgh Dean, will have a good selection (*fig. 44*). A favoured medium for portraits was bronze, while some portraits were simply sculpted from the stone used for the gravestone.[38] In the Calton New (Edinburgh), William MacGillivray, a famous early naturalist,[39] is favoured with the figure of a golden eagle rather than a portrait. The medallion has its counterpart today in the photographs of the deceased that are frequently attached to gravestones. The more one looks at Victoriana the more one realises that what we feel and how we show it has changed very little.

Ageism

ဆၣၡ

45. *Interesting dates, Auchtermuchty.*

Man's life's a vapour, full of woes,
He cuts a caper, and off he goes.
(West Linton)

A good game for children of all ages is noting the date of the oldest living person in any graveyard visited. I consciously started looking when, in one day, I noted someone (at Dairsie) who died aged 99. 'Tough luck,' I thought. Could I find a 100? I did, at Scoonie (Leven) and, shortly after, another at Hillhead Cemetery (above Logierait.)[40] But of course that just set the ball rolling.

The 101 came in Cupar Old, one of the biggest, most swanky cast iron stones I've seen, and 102 at Auchtermuchty, which proved something special: Henry Brown was born in 1799 and died in 1901 (*fig. 45*) so his life spanned three centuries. He was born when George III was king and thereafter saw off George IV, William IV and Victoria, and died when Edward VII was king. Recently an ex-neighbour wrote to say he'd been celebrating his 104th birthday. I'm keeping my eye on him! Not many seem to get much further (I'm open for references) and a jump in my record to 120 is considerable. This is the age on a stone

(*fig. 44*) in Kirkcudbright to William Marshall, king of the tinkers, who died in 1792 *at the advanced age of 120 years.* In West Longrigg (Lanarkshire) is a stone to *Thomas Wishart, who died 1752, aged 125 years.* That is still not Scotland's oldest recorded person. This distinction belongs to a lead miner (of all occupations) in Wanlockhead, where John Taylor died in 1770 at the *advanced age of 137.*[41] He was still working when 100.

At Cults (Pitlessie) a couple named Cockburn were noted as having been married for 70 years. I thought this was quite something, till reading of a Welsh couple who were married for 81 years and whose combined ages were 209. (She died in 1891 aged 105 when he was 104, and he lived on till 1893.) In November 2006, Britain's oldest person, Annie Knight, died, aged 111. She shared a birthday with the oldest man, Henry Allingham, 110.

The secret of longevity?

Alexander Gray at Eyrie, Aberdeenshire, a tenant at Mill of Burne
Died in the 96th year of his age,
Having had 32 legitimate children by two wives.

Animal Rights?

ഔ⊃ⵌ

46. The bull is from Tibbermore, a stone topped off with curling stones; the cow and calf is from Lundie.

BROWSING through the vast cemetery at East Wemyss I came on an unusually small stone against the boundary wall which noted *Bendie, drowned aet 10*. I can only assume this was a dog which had been slipped into consecrated ground,[42] something completely taboo; well nearly so, for most Scots people (and a great many worldwide) could immediately name one dog lying in an Edinburgh graveyard.

Yes, this is Greyfriars Bobby, his statue outby (*fig. 47*) and, along with Eilean Donan Castle and the Forth Bridge, one of Scotland's most photographed icons. His red granite stone is inside Edinburgh Greyfriars (facing the entrance, the spot covered in plastic flowers, *erected by American 'friends'*) not far from the largely ignored stone of his master, John Gray, who died in 1858. Everybody knows how the faithful Skye terrier lay on Auld Jock's grave for 14 years, the very image of faithfulness, at least till the one o'clock gun fired at the castle and he trotted off for lunch. Myths and some gruesomely bad films have distorted the story, of course; but it seems true enough that he was nearly impounded and then destroyed for not being licensed – until the Provost stepped in to pay the fee, duly noted on his collar (which is

47. Edinburgh's most-loved statue?

in the Huntly House Museum). Queen Victoria, passing through Edinburgh, always asked after his health. Bobby died at the good age of 16 in 1872.

Greyfriars Bobby's gravestone is of traditional type, but I have found one gravestone which is a dog (*fig. 48*). The location is Kiel Church, overlooking the Sound of Mull at Lochaline. For years I'd hoped to find a cat to balance this, but the nearest I could manage was the delightfully primitive moggie on a complex eighteenth-century stone at Clonmonell in Ayrshire. But I must confess to a yell of glee in Kirkintilloch's Auld Aisle extension when I came on a cat as realistic as the dog at Lochaline. I've also stumbled on a dog's cemetery off the A914 from Glenrothes to St Andrews near Burnturk,[43] and there's another in Colzium Park near Kilsyth, though a 'full' sign has now been erected. A military dog cemetery lies in Edinburgh Castle. The most incredible Pets' Cemetery I've come upon is at Edinburgh Piershill (*fig. 49*) where a large corner has been walled off and is crowded with hundreds and hundreds of pets: dogs, cats, budgies, the lot, their small stones or plaques rich with sentiment. In the middle, under shady trees, is the most extravagant memorial: a red granite pillar topped with the bronze head of an Alsatian ('Captain Davies').

48. Dog as gravestone.

In Corstorphine Parish Church a boulder marks the grave of a shepherd, John Foord, who was found dead on Corstorphine Hill in 1795 (at the original site of this stone maybe). A smaller

stone beside his grave tradition-
ally is the grave of his dog. In
Warriston Cemetery (Edinburgh)
the obelisk to artist Horatio
McCulloch shows his Skye ter-
rier Oscar. He had several Skye
terriers, both live animals and
shown in paintings – though no
paintings of his family – and had
a spat with fellow academician
Sam Bough, who encouraged his
bulldog to menace the smaller
animal. They had a long-
running quarrel. Bough lies in
the Dean cemetery. There are
several dogs to be spotted in the
Dean; one, on a mural, stands
below an arch showing a music
score – the opening bars of the
last movement of Beethoven's
Ninth Symphony.

*49. A corner of the Pets' Cem-
etery at Edinburgh Piershill.*

On the hearth of the bar-
rel-vaulted bar of Fernie Castle
Hotel in NE Fife (on the A92) is an epitaph to *Busdubh 1904-1921*, a
faithful black labrador of the one-time Balfour family who then owned
the castle: *This is my humble prayer, / Nor may I pray in vain, / God
make me good enough / To meet my dog again.*

*Near this spot / Are deposited the remains of one / Who possessed beauty
without vanity, / Strength without insolence, / Courage without ferocity,
/ And all the virtues of man without his vices, / This praise, which would
be unmeaning flattery, / If inscribed over human ashes, / Is but a just
tribute to the memory of / Boatswain, a dog.* (Byron, for the monument
to his dog.)

Animals in general are poorly represented on gravestones. The scrip-
tural words of Genesis 1:26[44] have had an insidious effect for centuries.
Such picturings of animals we have are almost entirely of farm animals
in scenes of ploughing, for example (*fig 100*) or, with no squeamishness,
a butcher butchering (*fig. 108*). Birds are notably absent for seventeenth
and eighteenth century stones. Fruit and flowers appear, but mainly as
decoration. There's a surprising frequent use of the pineapple; obviously

50. The Raven on the Rock, Skye.

in the eighteenth century this was new and exotic, and portraying it a status symbol.[45] At the Museum of the Isles (Skye) a modern memorial to the 22nd chief of the Glengarry, Air Commodore Donald MacDonell, has a life-sized, life-like raven perched on a rock topping off the stone, the work of sculptor Gerald Laing.

At Tayport there is one wildlife subject portrayed with a delicate accuracy I've never seen elsewhere – a row of sea shells (*fig. 51*). The same hand probably carved the nearby stone showing a winged rose above a clump of thistles. Someone was a naturalist. In Edinburgh Dean one stone portrays a dainty butterfly and chrysalis.

Mythical birds and beasts do appear. At Stirling Holy Rude, bordering scrollwork on one eighteenth-century stone rears up to end in strange beak-faced creatures, birds presumably; blood drips from the beaks, so the presumption is that they depict the pelican which,

51. Seashells, on one of Tayport's delicate stones.

in legend, fed its young with its own blood. Nobody however had told the sculptor what a pelican looked like *(fig. 52)*!

In Ayrshire there is a strangely different style of stone carving, with the subjects shown in bulgy, high relief, a sort of Rubens/Picasso voluptuousness which includes fat serpents and strange creatures looking like mermaids. An overfed serpent wends its way above the farming scene at Clonmonell; at Girvan and Kirkoswald you can find the mermaids.

This section can end with the words on a wartime monument to a mule:

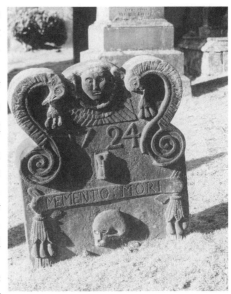

52. Puzzling symbolism, Stirling Holy Rude.

In memory of Maggie, / who in her time kicked / Two colonels, / Four majors, / Ten Captains, / Twenty-four lieutenants, /Forty-two sergeants, / Four hundred and thirty-two other ranks, / and One Mills Bomb.

Accidents Happen

ॐ☙

Here doth lye the bodie
Of John Flye, who did die
By a stroke from a sky-rocket
Which hit on the eye-socket.
(Durness)

ACCIDENTS are noted on a surprising number of stones. I lost count wandering round the large cemetery at East Wemyss, where fatalities at sea and in local mines are frequently noted. Some of the pit names I jotted down: Frances, Michael, Wellesley, Isabella, Victoria, Wellsgreen… Ships and the sea had many mentions. A dock inspector *Lost his life at Methil Docks,* 1941. In 1877 Andrew Thomson *Died from severe internal injuries received in the launching of a boat.*[46] All too common are individual mishaps, such as *lost at sea, aged 16* (Crail), and sometimes a whole crew perished like the eleven of the barque *Merlin* of Sunderland (most of them in their teens or twenties),[47] buried in St Andrews.

Elie, like most coastal places, has several stones mentioning loss at sea, one of them rather strange. At a meeting of paths by the east porch is a stone inscribed to *Charles Fox Cattanach, wife (sic) of James Smith, Ship Master… and James Smith her husband…* Apparently the minister mixed up names at the christening and the superstitious sea-going family insisted she kept her masculine names. At Kirkcaldy Old there's a depiction of a ship upside down with two figures clinging to the keel.[48] At Kirkmaiden the 1852 stone in the shape of a lighthouse was erected by one of the keepers at the Mull of Galloway light (*fig. 53*) in memory of his son.

Mining was not just for coal. At Wanlockhead, there's a stone to *James Brown who died from the effect of an accident in Leadhills mines, 1879, aged 24.* (But if lead mining doesn't sound very healthy, turn back to p. 50.)

One of the saddest stones I've seen on this theme is at Polmont Old, the result of a pit disaster in which 40 miners died when water flooded into the lower workings. Five men were brought out after ten days

underground. *Colin Maxwell, aged 58 years / Also his two dear sons / Walter aged 28 years / and Colin aged 17 years / who all died in the Redding Pit Disaster / on the 25th September 1923* (fig. 54).

Sometimes the stone's wording can be frustrating, like the one above, *the launching of a boat*. What exactly happened? Or what were *Joseph 13, William 10, both accidentally killed* (East Wemyss) up to with such unhappy result? Or the two men, (one at Daily, Ayrshire, another at Ceres, Fife) who were *shot while discharging their duty*?

53. *Kirkmaiden.*

Sometimes there's a certain black humour. Near Greenock a Roger Norton was unlucky: *Trying one day his corns to mow off, / The razor slipped and cut his toe off*. The result 'mortified' *i.e.* led to fatal gangrene. There was Tam Reid of Cromarty *Who was chokit to deid / Wi takin a feed / O butter and breed / Wi owre muckle speed...*

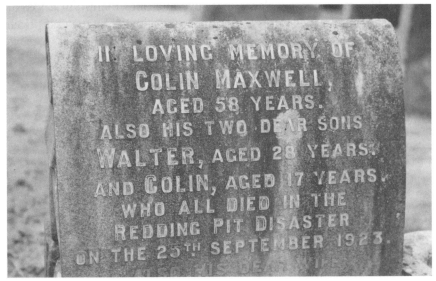

54. *Family tragedy in a pit disaster (Polmont Old).*

At Kinghorn there is a stone to a different sort of disaster which occurred in Kirkcaldy Auld Kirk in 1828. A renowned preacher, Edward Irving, ensured a packed church, but as he entered the gallery collapsed and 28 people were killed. There are other victims of this tragedy buried in Kirkcaldy Old, and there's a stone there to the minister of the church, John Martin, who was killed when his horse bolted and he was thrown from his carriage (1837). He was Edward Irving's father-in-law and grandfather of an Edward Irving who died aged 14 months, and is also buried here. The preacher Irving had fallen for one Jane Welsh while teaching in Haddington, though engaged at the time to Isabella Martin. He was held to this engagement and taught in Kirkcaldy for years before marrying. (He introduced Jane to a friend, Thomas Carlyle – and *they* married each other.) Irving's preaching and views became so wild he was deposed from the Church of Scotland, so he formed his own church. Tangled lives are nothing new.

An Auchtermuchty stone provides this inscription: *Joseph Anderson lost in the Tay Bridge Disaster 28th December 1879. Body found near Wick 4 months after...* Only 46 bodies were found, of the 75 people who died in that tragedy. The bridge's engineer, Sir Thomas Bouch, who would, not altogether fairly, be made scapegoat for the disaster, died before a year was out. A medallion portrait of the unfortunate man is over his burial place in the Dean Cemetery in Edinburgh. There's an engine driver, James Todd (buried in Kennoway), who was killed in an accident at Thornton in 1920, and Markinch has recorded an 1850 accident at Ladybank, in which 28-year-old David Wyse was killed. Britain's worst ever railway accident occurred in May 1915 at Quintinhill near Gretna, and involved a troop train; this crashed into a stationary local, then the midnight Euston-Glasgow express ploughed into the wreckage. In the resulting holocaust, 227 died and 246 were injured.[49] The striking monument over the graves is in Edinburgh's Rosemount cemetery: a large cross and mural tablets bearing all the soldiers' names.

Hardly surprisingly, today road accidents are not uncommon: *In memory of our son David... who died, aged 19, in a tragic road accident; Treasured memories of a devoted family, Raymond, aged 30, his wife Margaret, aged 29, and their sons, Ross, aged 4, and Stuart, aged 2, died tragically in a road accident; Karen, died tragically in a motorcycle accident... aged 22.* While I was writing this a newspaper provided a statistic pointing out that the year 2005, notorious for its natural disasters, had had 400,000 deaths from tsunami, earthquakes, hurricanes,

floods, etc. In the same period, on the world's roads, accidents caused the deaths of 2,000,000.

Road accidents have a history of course. A memorial near the summit of the Devil's Beeftub road from Dumfries to Edinburgh (A701) records a mail coach in 1831 being stopped by snow and the driver and his mate, determined to get the mails through, fighting on by foot, only to perish in the storm.

On a mound straight ahead as you enter Edinburgh Piershill is a stone briefly inscribed *The Great Lafayette*, a performer who died tragically in 1911, and who perhaps illustrates the transient nature of celebrity. Twenty carriages moved through crowded, silent streets for his funeral, but who, today, unless they go on a Festival Theatre backstage tour, has heard of this consummate showman? He filled theatres all round the globe: he was an illusionist, master of disguise, lion tamer and trainer of performing dogs – his favourite, *Beauty* (a present from Houdini) has a commemorative slab on his master's grave. A Jew of German origin, the brilliant Sigmund Neuburger spent nineteen years on the road under this stage name. A week into a show that involved a drama with a lion and a captive maiden, an electrical fault caused a small fire which instantly set the stage alight and created an inferno behind the safety curtain. Seven or eight people died, including The Great Lafayette. *Sic transit gloria.*

My own interest in mountaineering has my eye catching references to climbing and hill accidents. A medical student, Katrina Robertson, lies at Dunure following an accident on the Cuillin in 1982. A William Thomson died *mountaineering in Glen Coe* in 1961 (East Wemyss) while the graveyard in Glen Nevis has stones to fatalities on the Ben (Richard Smalley, 19) and the Buachaille (Ike Jones, 21) – and to Maurice Linnell (25) who was

55. *Ice axe and crampons, Arisaig.*

climbing with Colin Kirkus in March 1934, two of the leading climbers of the time, so a much publicised accident.[50] Kirkus recovered from severe injuries, joined the RAF on the outbreak of war and disappeared over Germany in 1943. Lesser hills could take their toll too; at Caputh is a stone to a 15-year-old boy, Ian Robb, who died in an accident on 486m Benachally Hill (North East of Dunkeld) in 1961.

In Lanark there's a mountain-shaped chunk of undressed stone to *Brian Seymour, Adventurer, who died after a short illness in 1989 aged 22 / This granite boulder was brought from Glen Etive... / to remind of his great love of God's hills and deserts. / Do not look for him or ask where he has gone / he had gone into the desert to look for God / who has all the best stories.*

More in way of pilgrimage I've visited the small graveyard at Struan in Skye to see the graves of the great friends who were the pioneers of Cuillin climbing, Professor Norman Collie and Skyeman John Mackenzie; a touching spot. Collie, a world famous scientist, spent his last years (during World War II) at the Sligachan Hotel. A more recent climber lies at Arisaig, a much loved figure; and when he died friends arranged for a stone with appropriate items to be erected at his grave – only to find the family had already erected one. Not many people have two gravestones, especially not with one adorned by an ice axe and crampons (*fig. 55*)

In late summer 1865 a big party of climbers, guides and porters left Chamonix to climb Mont Blanc, a party of several nationalities and varied abilities. Despite a storm they made a high hut and pressed on the next day. More storms swept in. The summit was only reached at 2.30pm and, in ever-worsening conditions, they were forced to bivouac. The storm however raged for a week. Five bodies were found, frozen to death, six were never recovered. There had been two Americans in the party and the Rev. McCorkindale of Gourock – and due to a mix up of identities one of the Americans rests under the Gourock minister's stone while he lies in a glacial tomb.

On the heather moors overlooking Glen More, with the Cairngorms splendidly arrayed in the background, is a simple cairn topped by a granite boulder (*fig. 56*). For New Year 1928 Hugh Barrie and Thomas Baird went in to Corrour Bothy; then, on the way out over Braeriach, they were overwhelmed by a blizzard and succumbed as they descended into Gleann Einich. Baird is buried at Baldernoch, Barrie here. A year earlier Barrie had written a poem in a Glasgow University magazine, some lines of which went 'When I am dead... Bury me not, I pray thee,

56. *Barrie's grave at Tullochgrue facing the Cairngorms (above)
and Irvine's grave in Edinburgh's Dean.*

in the dark earth... But take my bones far, far away... Find me a wind-swept boulder for a bier... so I may know... the swiftly silent swish of hurrying snow, the lash of rain, the savage bellowing of stags...' Baird's granite 'stone' at Baldernock is inscribed *A wind-swept boulder from the Cairngorms*.[50] Another granite boulder from the hill marks a grave at Sannox (Arran) for Edwin Rose, who was murdered high on Goatfell in 1889, a long-forgotten sensation.

Disasters in far places may have monuments to expedition members. There are two in Edinburgh Dean cemetery with bronze plaques showing arctic scenes (*fig. 56*). Lieutenant John Irvine sailed in *HMS Terror* in 1848, a venture under Sir John Franklin in search of the North West Passage, which ended with the ship being trapped in the winter ice. Dr Goodsir, serving as surgeon, sailed in 1849 in search of the Franklin expedition and again in 1850, expeditions fitted out by Lady Franklin, who strove for years to solve the mystery of her husband's disappearance in 1848.

Fellow Workers

57. The tribute at Carriden.

The grave's a fine and private place,
But none I think do there embrace.
(Andrew Marvell)

THERE is something touching in being remembered by fellow workers.
At Carriden, near Bo'ness, there is a cast-iron stone, the lettering unu-
sually clear (*fig. 57*), erected by cotton mill workers, *in loving memory
of Maggie McIntosh who was accidentally killed in Love Stewart & Co No
9 Woodyard Bo'ness, 10ᵗʰ July 1907, aged 14 years. A token of respect from
her fellow workers.*

At Dairsie a man is remembered *by friends in the bus depot, Aberhill*;
fellow railway workers mark a grave in Glen Nevis; a groom is com-
memorated at Abercorn by other Hopetoun House staff.

Servants could occupy a special place. Like Burntisland's big mama
Petronella who had been brought across the Atlantic as a slave and,
offered freedom, refused to leave, and lived to a ripe old age, her
speech fluent Fife: *In loving memory of Pete (Petronella Hendrick) born*

at Providence, Nickerie, Suriname, 20th August 1829, died at Hilton, Burntisland, 28th November 1917. / For over 60 years the faithful and devoted nurse and friend of the family of Robert Kirke of Reenmount and Nickerie, Suriname. / Gone to the Happy Land. Not a servant but as exotic is the stone at Anstruther parish church: *In loving memory of Princess Titana Marama of Tahiti, born at Papetuia Macrea 1842, wife of George Dairsie* [a merchant], *died at Anstruther 1891.* (Their son was killed in WWI.)

Tucked in behind the church at Muckhart is a stone saying *Matsuo. For 12 years Trusted Keeper of the Japanese Garden, Cowden. Died October 20 1937.* Perhaps it is as well he did not live a few years more. The war saw the beginning of the end for what were splendid gardens. I explored their decay just after the war; now you would not know they had ever been. It is surprising how often one comes on something in a graveyard that has a personal touch or ties in with other facts and fancies.

I would have missed the following but for a leaflet in the church at Glamis indicating a stone commemorating a Margaret Bridie who died in 1865. So? Well, she lived at Glamis Station, and each market day took a basket of her popular home-baked pastries the few miles to *Forfar.* And in the Howff at Dundee you have the name Keillor. Finding a lot of oranges along the shore, a woman of this name tried boiling them up – and invented marmalade.

The praise can sometimes be a bit over the top. Ministers especially seemed to be recipients of excessively fulsome praise (*fig. 58*), an example: *Rev D Dickson, 40 years in this church, St Cuthbert's, Edinburgh, an accomplished scholar and theologian, sound in doctrine, earnest in exhortation, in labours unwearied, acute in argument, expert in business, affectionate, generous, affable and accessible to all...* and 20 lines more in the same vein![51] Nothing could be more different, the ultimate in brevity, than a stone in Kirkcudbright: all it bore was the one-syllable name *Barr.*

From admirers rather than fellow workers is the striking monument to the actor John Henry Alexander of the Theatre Royal in Glasgow who died in 1851. This is in the form of a stage with all its embellishments (ornate tympanum, stage curtains, etc), and flanked by two figures holding the symbolic masks of Tragedy and Comedy. Comedy has vanished and Tragedy has lost her head: one hand indicates where it should be, while the other holds the mask by her side – an unintended piece of humour. Both monument and inscription are typical of Glasgow's

58. An extravagant memorial to a minister.

Necropolis: *Fallen is the curtain, the last scene is o'er, / The favourite actor treads life's stage no more. / Oft lavish plaudits from the crowd he drew, / And laughing eyes confessed his humour true, / Here good affection rears its sculptured stone / For virtues not enacted, but his own.*

In the Dean, Edinburgh, lie attractive stones for both Howard and Wyndham.

Children, the Children
ℰꙮ

59. The Logan family stone at Straiton (left) showing their loss: two infants, four boys, three girls; and three sisters remembered, Stobo.

STOPPING at Alvie graveyard with its fine airy setting off the A9 south of Inverness I came on the stone of *John Cumming and Jane Macpherson and their children, Robert, died 1819, aged 15, William, 1828, aged 17, Hector, 1834, aged 20, Mary, 1859, aged 52 and 5 sons who died in infancy.*

More than half their nine children died in infancy and only one, the solitary lass, had any life as an adult. This is sad, but it was also all too common in the days when a whole range of infectious diseases had no known remedy, diseases like cholera, typhus, diphtheria, smallpox, measles, scarlet fever, dysentery and consumption (TB), and when people lived in conditions that left them open to such risks, whether rich or poor. Stones with family tragedies like this can be seen in any eighteenth or nineteenth century graveyard.

At Upper Largo a stone close to the church has the strangely elongated figures of a couple, John Fortune and Isbel Ermit, and the sad story of their children John, Agnes and David, who died aged 9, 3 and 1, *the last two inter'd in the same cheist and same grave* (1766). A 1754 stone at St Vigeans (Angus) portrays two children and has the text *But Jesus said Suffer little children and forbid them not to come unto me for of such is the kingdom of God.*[52] A wife's dowry in those days included a shroud for herself – and infants.

These, too, are only the records we know about. Before the twentieth century those from the lower levels of our society were unlikely to have a gravestone. Paupers were given nameless graves. In the case of serious epidemics everyone might end in a common grave. Research will show that open areas in otherwise crowded graveyards may well be the sites of such burials, and fear has left them inviolate to this day.

At Dumfries (St Michael's) a bare, railed-off length in that crowded graveyard marks the resting place of 420 inhabitants who died in a cholera epidemic in 1832. At Brechin Cathedral a 1647 stone bore the words *Four risings of the moon saw six hundred slain by the plague: Learn of death, we are but dust and shadows.*[53]

Big families (rich or poor) were an insurance policy. A walk round a graveyard is no bad thing to remind us of just how fortunate we are. The following is reportedly to be seen in Fife and rather deserves to be authentic: *Of children in all she bore him twenty four / Thank the Lord there will be no more.*

The Victorians had cause to mourn the too frequent loss of children and erected monuments that reflect this, but if these appear over-sentimental then a walk round a contemporary cemetery will show no difference. The hurt shows, always. The kneeling marble cherub is in fact far less demonstrative than today's lavishly-texted and illustrated black marble, the site smothered in plastic flowers, plastic fairies and plastic geegaws.

The standard marble cherub kneeling with arms outstretched can be seen frequently, and any small angelic figure is likely to indicate the loss of a child. Few graveyards lack examples. In East Wemyss I made for a cherub figure on a pedestal (*fig. 60*) and found it was for a Michael Brown, known as Micky to his peers. A plaque at the foot indicated *A token of respect from his fellow workers in C & J Johnstons factory*, but then I read that the fifteen-year-old Micky had been *done to death*. That wording surely indicated murder. It did. I went back to the newspapers of the time and read the whole story.

60. *A cherub for a murdered youth.*

61. *Drumnadrochit's Boy Scout.*

He was a clerk at the linen factory down by the shore (which is still there) and in 1909 was sent to Buckhaven to collect the firm's weekly wages. He went up town for the tram, duly collected the money from the bank (still there) and, unaware he'd been followed, headed down School Wynd (still existing) – where he was beaten and strangled to death in the toilet (long blocked off) by an out-of-work thug. The murderer escaped to England but, weeks later, a 'Wanted' poster was noticed by a pedlar in Manchester (staying in the same digs as the murderer) when he was paying a licence in the local police station. Thousands met the train that brought the murderer back to Scotland and he was eventually hanged in Perth gaol. His prison letters to his mother were sold to the press. The papers gave screeds of detail. Much, it seems, does not change.

Looking at the stone showed that he had already lost a brother and sister (meningitis) and only one other sibling lived to adulthood. His mother lived into her nineties, so when I was teaching families from the area in the fifties and sixties some of them must have known her.[54]

A striking monument at Kilmore Church, Drumnadrochit, shows David Macdonald who died tragically at the age of eleven (he was either shot accidentally or

drowned). He stands by an ornate cross, dressed in full boy scout uniform (*fig. 61*).

At Monifieth a 1734 stone is typical of an eighteenth-century child's stone: *Here lyes a harmless bab, / Who came and cryed / In baptism was washed / And in three months old he dyed.* Another I collected years ago, but have lost the provenance, went: *I didn't ask to come on earth / So who ordained my little birth? / My parents coldly lie in clay / But, as I'm here I'd rather stay.*

Today's most elaborate and decorated stones (sometimes OTT) are for children – and they are not uncommon – but I defy anyone to stand dry-eyed at the tragic group of children's graves in the hillside cemetery above Dunblane.

The Pity of War

ဆာ‌က္ခ

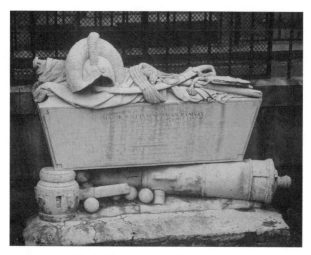

62. Military swank, Inveresk.

EARLY military or naval graves are usually marked with all the drum-thumping symbolisms expected. The OTT Inveresk example is typical (*fig. 62*). I've seen one or two Lucknow commemorations and several VCs. At Culross there's a new stone to a Colour Sergeant Stewart McPherson who won a VC *at* Lucknow in 1857. But to cover the whole range of war in its global proliferation would need volumes. I'll bring it nearer to today. I'm a survivor of war and I did my two years in the RAF in situations that brought two service medals. I hate war, its horrors, its stupidities, its glorifications – which is why I find a war memorial like the one at Strathmiglo cemetery moving: a simple wooden cross on which are pinned small bronze plaques bearing the name of the village's lost ones. There are 49 for World War One and 5 for World War Two. In East Wemyss there is a stone I find inestimably sad as I think of the mother adding and adding sons' names to the family stone: *1915, 1916, 1917*. And what graveyard anywhere doesn't have at least one of the standard, simple, dignified War Grave Commission stones? In Edinburgh Calton New, for example, just one stone records

63. The ship names from Douglasbank.

five casualties, from *MV Athel Templar*, with the all too common words *Known Unto God*.

Not so long ago I looked round Montrose's various graveyards and cemeteries. Sleepy Hillock occupies a woody slope overlooking the Basin, a beautiful spot, but I came away stunned. There were rows and rows of those identical stones, all for RAF personnel. I walked along one row of 36 stones then, barely seeing, walked back noting down the ages of those killed: 22 30 21 23 28 24 20 24 20 24 20 21 20 21 25 22 40 23 25 22 25 19 19 26 29 23 19 19 23 19 22 18 28 33 25 22.

Douglasbank above Rosyth has a similar pattern, circle on circle of stones for those lost at sea. From one circle alone I copied down the names of the ships on which they served and died (*fig. 58*). There were names of famous warships (*Rodney, Illustrious, Prince of Wales*) and modest craft, like *HM Yacht Sylvania*. One of the stones had Arabic text for an Indian, Youssouf Goulam Hussain, one was for a German, Bruno Lange.

At Comely Bank (Edinburgh) there are rows of grave slabs (225 individual burials) with crests of every imaginable regiment, from Britain, Canada, New Zealand, Australia and a solitary soldier of the Finnish Legion. A strange mix? Just over the wall was the Western General Hospital, which was used as a 1000-bed Military Hospital in World War One.

64. Polish war graves, Perth Wellshill.

Last Christmas Day I visited Perth's Wellshill Cemetery (*fig. 64*) where the frost lay on the long shadow patterns of war graves, all with the names of Polish servicemen, their loss of country and life a doubling of pain. I find it hard to write these words. The pity of war indeed.

To cheer, let me quote what is written on a red granite stone that sits among the ranks of grey slate at Ballachulish: *Alistair MacDonald was one of the three Argylls who made the epic escape across occupied France in 1940. On being recaptured they outwitted the Germans by speaking Gaelic and passing as Russians. After many vicissitudes they reached Spain and were eventually smuggled home.*

A different sort of escape story comes from the time of the Forty Five, the last serious warfare on British soil, I suppose. In Glen Moriston is Mackenzie's Cairn and grave, where a soldier of that name was killed in the aftermath of Culloden when the Hanoverian forces were desperately trying to capture Bonnie Prince Charlie. There was a huge price offered for the Prince's capture, dead or alive. Mackenzie, who knew he bore a striking resemblance to the Prince, became involved in a skirmish here and as he lay dying blurted out at the redcoats "You have slain your Prince!" Believing this, they cut his head off and sent it off as evidence and, for a critical time, the search for the Prince was abandoned. In the Old High kirkyard at Inverness the wounded from the Battle of Culloden were sat on a stone and systematically shot, with another gravestone providing a steady rest for the assassin's gun.

Long Coats and Couthy Bunnets

𝕊𝕠ℂ𝕣

THIS section should perhaps be in Part Two, as it concerns the portraying of figures; but it sat uneasily with the two big themes of religion and trade, so is here, to add a lighter touch to what has become somewhat sad and serious.

When contemporary eighteenth-century figures are shown (not common) they are, naturally, dressed in the costume of the period: long coats with big pocket flaps and huge cuffs with innumerable buttons and, often, buckled shoes. In the Howff, Dundee, there's a couple (hand in hand) in the earlier – passing – Stewart extravagance, the man with a great tumble of curly hair and fancy waistcoat, his wife in a full-length dress with low-cut neckline. Pepys might have pictured them.

Most costumed figures are country folk, with bunnets on head rather than a tricorn hat, and their own hair rather than a wig. They all look *comfortable*. A stone at Uphall (West Lothian) shows a figure in coat and bunnet leaning on his stick as if just pausing in a walk round his fields. I always expect his wee dog to pop round the stone, tail wagging. At Temple (Midlothian) the farmer stands in Sunday best with his two well turned out boys holding onto his coat and his hand resting on the head of the elder. Methven has a flat stone with a ship at one end and a figure at the other with his coat flared out as if the wind had caught it as he stomped the deck of his ship. Russell Crowe perhaps.

At Auchtertool (Fife) the Reverend D. Martin lies on a slab, in knee breeches and minister's gown, the Bible by his head. The finest detail of any costume must be the farmer figures (sowing and reaping) on the back of the famous Father Time stone in Corstorphine (*fig. 65*). Look at the ribbons on the sower's stockings! The picture, alas, doesn't show his head; he hasn't one, vandals have seen to that.[55]

There are far fewer figures of women shown; 'couples' at Teviothead and the Howff (Dundee), the family group at Monikie, the three sisters at Stobo, are unusual. The charming Monikie family group consists of small figures of mum, dad, boy and girl, all with period costume clear.

65. Costume details: above, the Bruce Aisle figures (Culross Abbey Church); bottom left, Edinburgh Corstorphine; bottom right, a nod to Kamasutra from Calton Old.

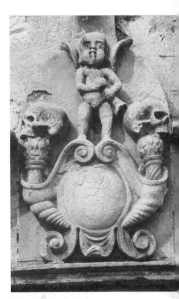

66. Pencaitland (East Lothian) is rich in figures like the three shown here.

Forgan has a well-dressed girl, a huge crown above her head. A stone in a wall at Murroes of a figure holding a heraldic shield wears a ruff and the multi-banded padded epaulettes of the early seventeenth century. Sailors' costumes can be seen on one of the sheltered stones at Perth Greyfriars.

Earlier in period again, and with their aisle inside the church at Culross, is the Bruce family, the couple shown lying together as traditional marble effigies while before them kneel the figures of their three sons and five daughters, every detail of costume clear (*fig. 65*).

At Garvald (East Lothian) carved in the rich red sandstone of the area, a man is shown, head and shoulders, holding up a skull to his earnest gaze (shades of *Hamlet*), with an enormously-sized, no doubt very fashionable, cuff. The features are lifelike and this could well be a portrait.

At Garvald I also noticed a surprising female figure with bare breasts but I've seen others since.[56] One stone in the Old Calton (Edinburgh) is quite erotic and would fit happily among the carvings of an Indian temple; the bare breasts and split skirt certainly are not the norm in Presbyterian eighteenth and nineteenth century Scotland.[57] Just along the road in the New Calton is a bass relief portrait of a douce Solicitor General Andrew Skene over a scene of 'Misfortune soothed by Wisdom' and flanked by two life-size naked boys. The Victorians can always surprise.

PART TWO
The Great Eighteenth Century Folk Art
৯০৫৪

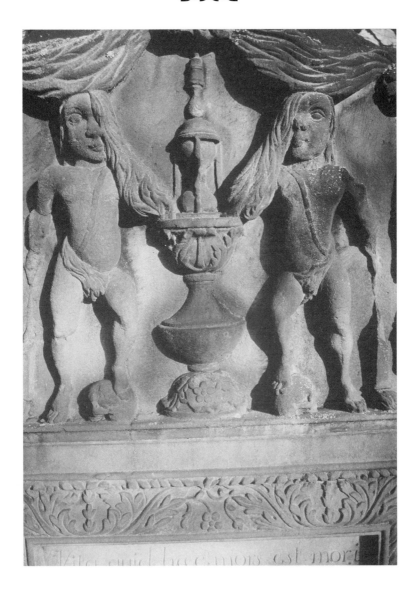

67. (Previous page) A fascinating but puzzling stone from Edinburgh St Cuthbert's.

A Folk Art

When first I drew the breath of
Life, I nothing knew at all, yet
Long before my death I knew
That I with Adam fell.
My body lays near to this stone
Waiting the morning call,
When Christ will take me by the
Hand: He is my all and all.
 (Nether St Cyrus)

As you walk into the graveyard at Pittenweem one of the first table stones has this wording: *Heir lyeth the corps of a famous man David Binning skipper and late ballie of the brugh and husband to Agnes Adamson who departed the first of Sept.ʳ 1675 his age 36 (fig. 68).*

 'The Modesty Stone' (to locals) very clearly shows the confident moral and social position David Binning occupied. The Trade Guilds of the eighteenth century had commerce pretty well sewn up, which

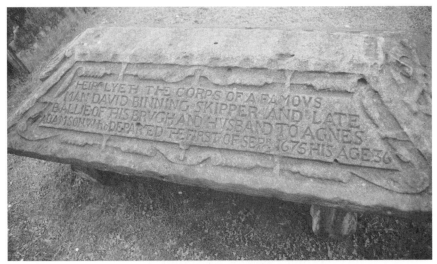

68. The Modesty Stone, Pittenweem.

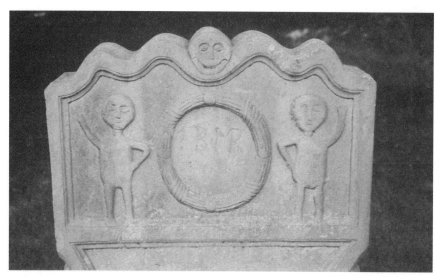

69. Not a Torphichen Highland Fling but primitive Resurrection figures.

was nice for them and is why there are so many stones indicating their ventures. Lesser mortals simply did not have gravestones – and pretty nasty lives as well – nor did things change much through the Victorian century that followed: the 'haves' and the 'have nots' co-existed, with the latter still not likely to have gravestones.

A certain amount of self-righteousness, I feel, along with religious zeal, ensured gravestones would be used for preaching as well, even it it was just a later insertion of *Memento Mori* on an expensively decorated earlier stone. At Logierait, for instance, the farming plough symbol of sock and coulter becomes a minute part of the overall rich decoration. Trade could afford to pay the best masons, and the best masons have left us a national treasure which we have largely failed to value.

Some of the symbols shown appear in the *Emblem Book of Francis Quarles* (1639/1777) from which they have been copied and spread, but by far the greater part are obviously the inspiration of local talent, which makes the subject far more interesting and, conversely, is where today's cemeteries appear so lacking in novelty: everything now comes from copy books and computers. One of the delicate stones at Tayport has an angelic figure copied from a platter of the Mildenhall Roman hoard.

What follows is not an in-depth study: there simply isn't space and Willsher is there for fuller details. I just hope I can explain enough to make readers want to know more.

Symbols of Mortality
ಚಿಂ

What are our ages but a few brief
waves from the vast ocean of eternity,
that breaks upon the shores of this our world
and so ebb back into the immense profound.
(Errol)

Memento Mori – Hora fugit – Disce mori – Requiescat in pace.[58] These
are some of the Latin tags I've met with on gravestones that were very
much part of eighteenth century iconography. If you look carefully,
with practice, you'll notice the words of the most popular tag, *Memento
Mori,* have sometimes been added to the stone by a later hand, zealots
perhaps objecting to a stone's mere ornamentation and adding their
Calvinistic graffiti. As if we needed it! Our stones in fact are a delightful
mix of the extremes, to the extent we can split the symbolic depictions on

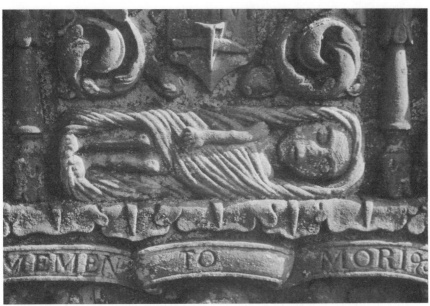

70. Shrouded figure, Edzell.

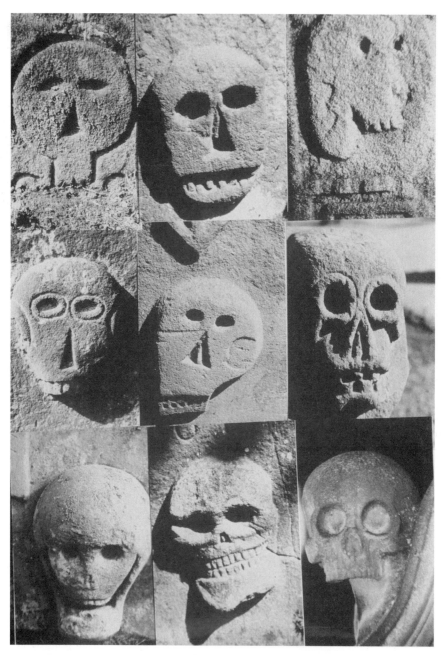

71. *The death's head or skull is about as common a symbol as the winged spirit (often balanced at foot and top of a stone) but can be portrayed in an endlessly fascinating variety of styles.*

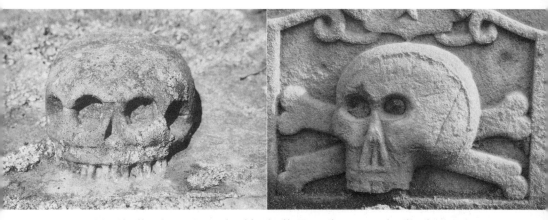

72. Skulls: the unique double skull, Torryburn, and a lively Queensferry skull and crossbones.

gravestones into the two categories of 'Symbols of Mortality' and 'Symbols of Immortality', these being warnings that we die and reminders of everlasting life, often, of course, appearing on the same stone. In a less literate century the meanings would be plain, today less so. A friend of mine, as an adult, wandered into the graveyard at Kinfauns, and noticing the proliferation of skull and crossbones assumed the River Tay must once have been a pirates' lair! (*Fig. 72.*) Several times recently, in graveyards, people have asked me questions like "Why a skull? ...Is that a coffin? ...Why has that head got feathers coming out of its ears?" Some explanation is in order.

Skulls (Death Heads). Skulls are the biggest eye-catcher and there are certainly enough of them, coming in every style imaginable from the primitive 'tumshie heid' (turnip head: think Hallowe'en lantern) to some an anatomist could use in a demonstration class, from skulls deeply incised with black holes for eyes, to skulls in bold relief or sculpted whole, often decorating the top outer corners of a stone – the only place where they may usurp the precedence of the 'winged spirit'. They are frequently shown with bones (noted next) or seemingly balancing an hourglass (many at Peebles) or simply as one of a group of symbols, these sometimes seen in a row with a ribbon or tasselled cord linking them together (Logie Pert, Tealing, Methven, Inverarity – *fig. 79*). Skulls can also be shown in profile or three-quarters profile, with strange effects (Dunkeld Cathedral ruins) and sometimes look as if they were wearing goggles. Clackmannan has odd skull designs of its own, Garvald has that costumed figure holding up a skull before his eyes. There are rare, early, winged skulls (Bowden); at Tranent and

Pencaitland the skulls have bat's wings. Torryburn has a unique double skull (*fig. 72*).

Bones. These will frequently be shown in combination with a skull and not just as the 'pirate' skull and crossbones (*fig. 72*) but singly and in all manner of other combinations, and as quite recognisable bones too: fib and tib, femur, jaw bone, hip bone, etc. The skull and cross-bones are not indicative of the grave of a plague victim as I've heard suggested. At Torphichen the mason was so enthusiastic about bones that the balancing pair of wingèd spirits were only given one wing each in order to fit them in. The same hand surely created the similarly crowded stone at Muiravonside, clearer but less known. At Torryburn crossed bones have the addition of an arrow embedded in a heart.

Hourglass. A very common symbol (*fig. 73* and many more!), even more meaningful in those days when real hourglasses might be used for timing the sermon in church, for instance. They can be shown upright, indicating 'the sands of time are sinking' or lying on their sides, inoperative, dead, as we all will be. Flaming hourglasses are rare but they are quite often shown winged (*fig. 77*),[59] presumably with the suggestion of death winging near, time flown or whatever (they are symbols), sometimes held up by a figure or Father Time himself (*figs. 74, 75*). Rhymes often use the symbolism: *My glas is run / my tym is set / and for my sins I / should repent* (Culross), *As runs the glas / man's life doth pas* (Nether St Cyrus).

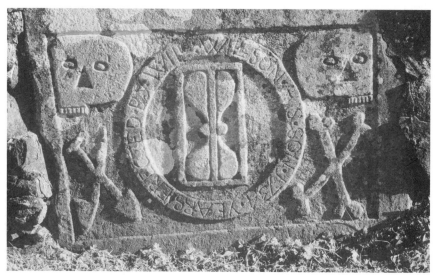

73. An hourglass given prominence at Minigaff.

74. *Father Time with scythe and hourglass, Corstorphine.*

75. *Father Time with hourglass encouraging a skeleton with dart to extinguish the candle of life (left).*

Father Time and other unfriendly figures. Father Time is usually shown holding an hourglass and/or scythe. The best I've seen is at Corstorphine: a leering, bearded figure, naked but for a swaddling round his loins, hourglass held aloft in one hand, huge scythe in the other (*fig. 74*). Not a common feature in Scotland; Willsher lists six. Those at Kinnair and St Madoes sprawl rather wearily, resting an elbow on a skull.

Death may be indicated in other figures; is he, for instance, the robed figure, spade in hand, stabbing a javelin into a fallen victim on an ornate stone at Stirling Holy Rude?[60]

Angel of Death may be indicated, as in a stone against the church at Abercorn, winged, holding up an hourglass and with weapon in hand. (This is usually the prerogative of a skeleton.) Such figures may have spears, darts or arrows as their weapons of death. You can see crossed arrows (Haddington) or an arrow through a heart (Elie, Cargill, Kirkgunzeon).

Skeleton (see *fig. 137*). Continuing this theme, Arbroath Abbey and St Andrews Cathedral both have marvellously dramatic pictures of a skeleton stabbing their victim. The St Andrews' museum is rich in skeletons, none of them up to much good. On the other hand a skeleton below St Rule's Tower nearby seems to be lying in a hammock, and at Elie one is rolled up in a scroll so only the skull and some ribs show at the top and bony feet poke out at the bottom.[61] There are several evocative skeletons

76. The painted ceiling at St Mary's, Grandtully (Aberfeldy) which has death claiming a victim, a scene known on several gravestones (right).

in Edinburgh Greyfriars, one mural dancer facing the kirkyard entrance. Skeletons are not uncommon and appear horizontal, vertical – or seemingly dancing. Libeton, Biggar, Stobo, Kirkoswald have examples. By far the finest I've seen is at Alloway Old Kirk (of Tam o' Shanter fame) where Father Time seems to be cheering on a skeleton with dart in one hand but, with the other, about to snuff out a candle (*fig. 75*). Burns couldn't have done better. *Deathbed* scenes may have a skeleton delivering a death blow from a dart, but are rare. A superb picture of this can be seen on the painted ceiling of the old church of St Mary's Grandtully (*fig. 76*).[62] A tailor's stone at Kettins puts it in words: *The King of Terrors dare withstand / Who hath the glass and dart in hand.*

A skeleton lying horizontally may simply represent the dead person, and if winged figures are blowing trumpets over it the meaning is quite cheerfully different, and discussed on p. 91.

Corpse. Either naked, or shrouded (*fig. 70*), depictions of dead humans are rare. There are versions of the former at Abercorn and Cargill, of the latter at Tealing, Edzell and Kirkcowan – and not many others are recorded. Deathbed scenes are also rare: Strathmiglo, Kingsbarns,

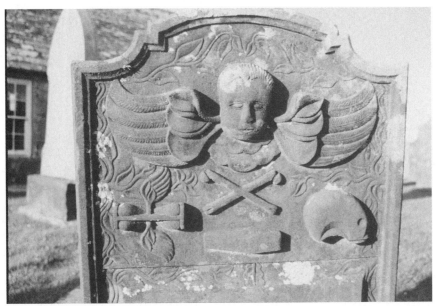

77. *A classic mix of mortality symbols, topped by a winged spirit (Kirkmaiden, Galloway).*

Newtyle (detail on a table stone). Nudity was obviously not 'correct' as even Adam and Eve are given diplomatic coverings.

Coffin. These usually appear among other symbols on a stone rather than by themselves. Sometimes they may be found crossed, and occasionally the poles for carrying them are shown. (Eassie, Meigle, Maryton near Montrose, the Howff, Dundee, and see *fig. 11*.)[63]

Bells. A funeral procession would often include the ringing of a hand bell (*fig. 78*) and this image (with or without a hand holding the bell) makes a fairly rare appearance, sometimes coupled with the coffin symbol, as at Greyfriars Edinburgh and Maryton near Montrose. There's an early example with two bells sunk in the grass at Kilmore above Dervaig, Mull and on a fine flat stone at Daviot which suggests a Highland tradition of ringing bells at a funeral. There are several in Angus, a good one at Kirkton of Glencairn in Dumfriesshire and at Tranent.

Sexton's tools. Almost always shown as crossed implements such as pick and spade,

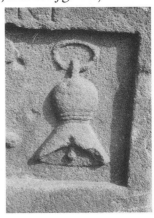

78. *Handbell, St Cyrus parish church.*

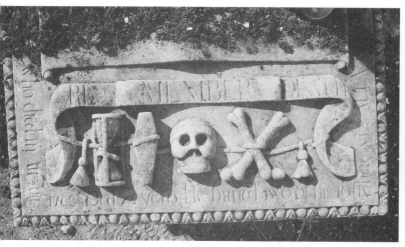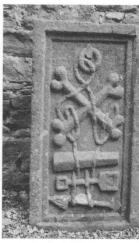

79. A typical bound 'ribbon' of symbols at Inverarity and, unusually in vertical form, at Tealing, both in Angus.

spade and turf cutter, sometimes set to balance crossed bones in a stone's design. They are not very common, but I recall Coupar Angus, Lundie, West Linton, Muthill (*fig. 79 r.* shows a single spade).

Scythe. Usually shown crossed as a pair, but sometimes crossed with a dart or a club (Logie) – and held by Father Time along with an hourglass (*fig. 74*).

Extinguished torch. A fairly clear indication of life burned out. Not common, though stones are sometimes flanked by pairs of torches, joined base to base, the upper flaming, the lower doused.

Ribbon Strips. Many of these symbols are shown in various forms and combinations. Sexton's tools, scythes, coffins and darts, may be shown crossed (often to balance crossed bones) or crossed with other symbols: scythe and club, scythe and dart, etc. Often, at the 'foot' of a table stone they will be lined up in a strip, sometimes with a cord or ribbon running through and linking them. Meigle has some fine groupings such as hourglass, bell, crossed bones, coffin (with carrying poles) and skull. The Howff in Dundee has many; any place with lots of table stones will give samples. In another form they may be shown vertically on the two outside edges of a stone; this is much less common (*fig. 79*).

Green Man. Where to place this figure? Was he malign or benevolent? He was ancient and pagan certainly, though that is about all we can say. He was also commonly seen in church architecture and in graveyards. The face, usually human, sometimes catlike, most frequently has vegetation issuing from the mouth. Latterly the original

80. Green Man, Auchtermuchty.

concept could be reworked simply as a pattern or space filler, some-times almost abstract – but the hint of mystery remains.

St Andrews' Cathedral Museum has many Green Man faces (two on the first stone you meet, at the entrance), there are some in Perth Grey-friars, one at Livingston, a splendid one on the back of the Father Time stone at Corstorphine, one at Tealing, one at Stirling Holy Rude and a splendid one at Auchtermuchty (*fig. 80*). Very occasionally figures dressed in leaves appear, as at Dalgarnock (Dumfriesshire) or Meigle.

This vivid and varied reminding of death is not something we see today. The topic of death is almost taboo. People no longer die, they are *Taken From Us, Went from Us, Passed Over, Passed On, Departed this Life, Fell Asleep.* In these earlier times, however, Mortality was only one side of gravestone imagery, and the greatest number of images and texts indicate hope of Life Everlasting.

...I entered into life on the condition that I should depart out of it.
(St Andrews Cathedral, 1582)

Symbols of Immortality

Here lyes within this earthen ark
an archer grave and wise
Faith was his arrow, Christ the mark
and glory was the prise
His bow is now a harp, his song
doth alleluiahs dite
His consort walker went along
to walk with Christ in white.[64]

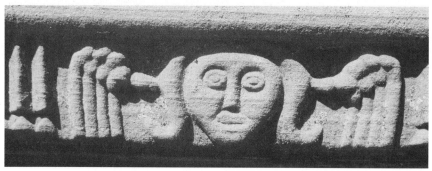

81. Table Stone detail, Kirkpatrick Durham.

Winged Spirits. Quite the commonest symbol found is the 'face with feathers coming out of its ears', the winged spirit, usually found topping off any stone's decoration, its setting on top of the stone symbolic in itself: the soul of the person interred has winged off to heaven, Christian hope made sure. All this symbolism would mean so much more to a population partly illiterate and who were Christian believers in a way hard to imagine today. Most of the seventeenth century saw Scotland bloody from wars that had religious beliefs and practices as the cause, and the eighteenth century was hardly noted for tolerance.

Winged spirits very soon become fascinating to graveyard visitors, for the variety is astonishing, both in what is shown and how it is sculpted. There was no pre-cast, mass production in those days, so every depiction is unique though, in certain graveyards or areas, the

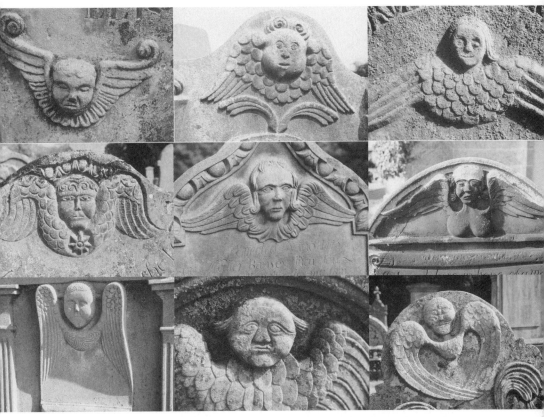

82. Winged spirits in many forms (left to right, top to bottom) from Polmont Old, Errol, Monikie, Monifieth, Colinton, Liberton, Forgan, Edzell and Glamis.

hand of one master may be suggested. This is folk art and folk art of the very best. The faces can be everything from 'tumshie heid' to classic revival – where they did copy – and one will come to recognise common types. There can be a range of hairstyles shown and expressions can vary from sober to impish. In Angus there was a delight in showing neat little winged spirits in pairs (*fig. 83*). On a butcher's stone at Abernyte (Angus) the wings overlap, but they can do anything: wings up, wings down, swallows' wings, wide wings, feathery bibs, complete abstracts. Monifieth on the Angus A930 coast road east of Dundee has a delightful concentration of winged spirits.[65]

Winged Angels of the Resurrection. One of my favourite depictions must be these figures which can be delicately or vigorously shown, always entertainingly. They usually come in pairs blowing on trumpets,

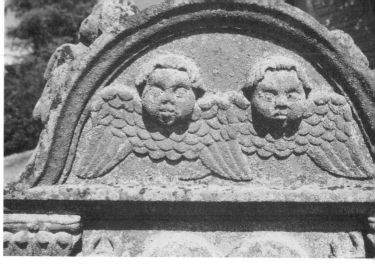

83. A charming winged spirit at Monifieth and a pair of winged spirits at Abernyte.

depicting the belief that 'the trumpet should sound and the dead shall be raised'.[66] Some examples can be found at Muiravonside, Queensferry and Perth Greyfriars (*fig. 84*), where a 1774 stone depicts two very junior angels blowing for all their worth while seemingly having trouble in holding on to their nappies! Another in Perth Greyfriars (Austin Family) sadly commemorates the death of five children, a stone lavish with detail: above cherub-like angels is a crown, while their feet rest on a sideways hourglass and a skull and bones, the stone flanked by pillars with Green Men-like figures and the inevitable *Memento Mori*. At Corstorphine, against the church, two chubby figures seem to be desperately blowing their short trumpets while struggling not to slide down the pediment.

As mentioned earlier, the trumpeters may be playing over, at or down to a skeleton. A small Meigle stone, rather faint, has the blast going into the very ears of the dead, the figures seemingly robed entirely in

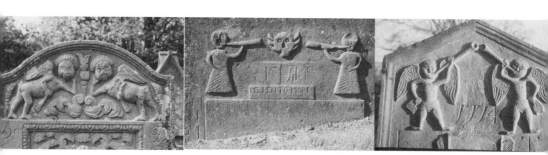

84. The trumpets of the Resurrection are shown in many ways, examples here (left to right): Monikie, Edzell and Perth Greyfriars.

85. Forteviot's primitive representation of the Resurrection.

feathers like some Inca priests. The skeleton holds the usual dart and hourglass and the half-smiling winged spirit has a fine *torc* of feathers. Meigle has several of this symbol, including a deeply incised table stone with huge angels with flowing loincloths and the skeleton surrounded by six skulls. There's a vivid individuality in these sort of stones. Some (Muiravonside, Edzell) have stopped playing and peer down as if to observe the result. The group at Queensferry appear to be the work of one mason.

The *Resurrection angel* – or often two – may also be shown blowing trumpets over figures who are rising up towards heaven, waving vigorously as they go. There are examples at Muiravonside, Monimail, Forteviot (*fig. 85*) and Torphichen (*fig. 69*); the last look as if they are dancing a Highland fling.

There are occasionally purely decorative cherub figures or the sort of *putti* seen on religious paintings of the Renaissance, or even a tiny face used as a 'filler'. Some are very entertaining, like the cherub at Tranent (*fig. 91*) who wields judgmental sword and scales.

Deathbed scenes. Rare. One at Strathmiglo is now badly weathered

86. Newtyle Death Bed scene.

but there's an entertaining one on a tailor's table stone at Newtyle (*fig. 86*). A figure waves from what looks like a basket, while his spirit soars off. A figure stands behind and another holds open the Book. To make the symbolism quite clear the basket-like object is inscribed *Death Beade* (OK, he couldn't spell either). At the Howff a curtain is being pulled across a scene: *finis*, a Quarles motif.

Crown. The apostle Paul promised believers 'a crown incorruptible' or 'a crown of righteousness' and Peter promised 'a crown of glory which fadeth not away'.[67] In St Cuthberts in Edinburgh (*fig. 87*) there's a naked angel (lower half diplomatically in cloud) holding out a crown, with a hand (from another cloud) reaching up for it, and this is clearly explained in the text carved above: *Be thou faithful unto Death and I will give thee a crown of life Rev. 2:10*).[68]

With all that I'm just surprised there are not more crowns shown. The Austin stone just mentioned (Perth Greyfriars) is one of several that particularly use this symbol in connection with the deaths of innocent children. There's a clear crown at Ratho, and the fine tailor's stone at Forgan has a 3D effect from the crown having a hole through the stone (which came first, I wonder: hole or design?), the Errol stone (*fig. 91*) is a superb example, and there's one for a weaver at Monikie. Crowns shown over hammers or the shoemakers' oddly shaped cutting knife are trade symbols, dealt with in the next section.

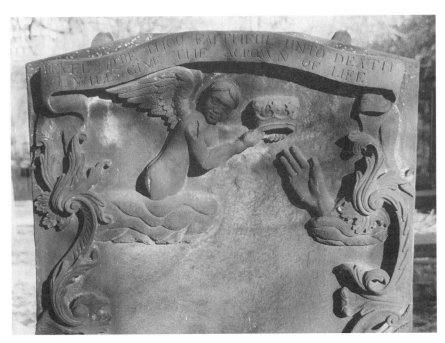

87. *The angel offering the Crown of Life; Edinburgh St Cuthbert's.*

The Glory of God. This sometimes shown as a radiance beaming out from a face. Very rare. Willsher mentions St Vigeans and there are a couple at Milnathort Orwell and one at Strathmiglo. God, of course, would never be portrayed, but in Perth Greyfriars a hand symbolically takes the place of the Deity (see p. 111).

Anchor. This may simply be a sign of a sea-going profession (see p. 123) but can also be symbolic of Christian hope; Heb. 6:19 declares 'Which hope we have as an anchor of the soul, both sure and steadfast'. An anchor seemingly upside down is pointing to being anchored upwards, in heaven (*fig. 133*).

MINOR SYMBOLS

Open Book. This can be taken to be the Bible[69] or perhaps specifically hoped to realise the words of Phil 4:3 about having *names written in the Book of Life*. There are a couple at Lilliesleaf and West Linton, Dryburgh and Newbattle, and it is very much a favourite symbol in the Borders. Ministers frequently had the Bible shown on their memorials. Schoolteachers would be shown holding a book. An open book (often marble) for carrying the inscription became popular in Victorian times and is still often chosen today. Cupar New has many (*fig. 42*).

Finger pointing upwards, like the anchor inverted, is pointing out the assurance or hope of immortality, heaven always being thought of as 'up there'.

88. Kirkton of Glencairn: a late use of the snake symbol.

Snake. A snake forming a circle by biting its own tail is a symbol (pagan originally) of eternity or everlasting life. Torphichen has two examples, and whenever you find a circle (itself a symbol of immortality) it is worth a scrutiny – it might be the snake image. I've also seen such at Stirling's Holy Rude, Perth Greyfriars, Muiravonside and elsewhere, with a remarkably late one at Kirkton of Glencairn near Moniave (*fig. 88*).

Stars appear on occasion, rather as useful 'fillers', one feels, but the symbolism remains today, as a 'star of hope'. Culross Old West has a stone with star and heart. The star can also be a hex symbol, a protection against evil.

Hearts are not uncommon and can either indicate divine love or human love, the latter usually occurring as a heart shown between husband and wife initials in similar style to what appears on mar-

89. A 'heart between initials' example from Kirkcaldy Abbotshall.

riage lintels on houses of the same period (*fig. 89*). Variety abounds: the crown and crossed fishes stone at St Vigeans has a heart between initials, at Monifieth a Biblical text is enclosed in a large inverted heart, at Collace a pair of winged spirits wear pendants with hearts on them, at Meigle a heart on the bib of a winged spirit is pierced by crossed arrows, there's a large arrow-pierced heart at Kilpatrick Durham, at Errol three hearts are shown so they look a bit like a shamrock leaf, they can be upside-down as at Bolton… And butcher's instruments sit on a heart at Abernyte (*fig. 108*) but a simple heart among other symbols is probably just showing love and devotion to God. There

90. Flaming heart; Edin-burgh Liberton.

are occasional flaming hearts (*fig. 90*). (To this day the flaming heart of Jesus is a potent symbol in Catholic countries.) The heart is the sole element on a stone at Dollar, Tulliallan has an unusually large number of hearts and there are even winged hearts (Banchory Devenick). A heart upside-down or pierced by darts will symbolise Death.

Flaming torches represent eternal life. An ornate stone at Errol (*fig. 91*) and a tailor's stone at Monifieth has them in pairs decorating the edges of the design.[70] An extinguished torch, or upside-down torch, is the corollary – often shown in the same design. The pairing of torches is similar to having *caryatids* (pillars in human form – like those praying on the Perth Greyfriars Austin stone) or even plain architectural pillars.

Roses and *Lilies* have something of the same symbolism of love and devotion,[71] but most flowers and plants (like thistles) on gravestones are simply decorative, though *palms* and *vines* certainly have Biblical connotations.

Doves are almost the only bird to appear, and that more generally in Victorian times. They can be fully sculpted birds perching in a variety of attitudes, or simply carved above an inscription.

As symbols declined there was more emphasis on finding and using an appropriate verse from the Bible, which peaked in Victorian years,

91. Attractive symbol stones: from Fintry, Minister and Bible;
Errol, a richly decorated stone with the Crown of Life; Tranent,
the sword and scales of judgement.

an altogether more cheerful assertion of faith than the constant hector-
ing of the earlier *Memento Mori*! In no sort of order as I look through
slides I've seen the following: *The eternal God is thy refuge and under-*
neath are the everlasting arms. (Deut. 33:27); *Hid with Christ in God*
(Col. 3:3); *Looking Unto Jesus the author and finisher of our faith* (Heb.
12:1); *With Christ; which is far better* (Phil. 1:23); *Blessed are the dead*
which die in the Lord (Rev. 14:13); *The Lord gave, and the Lord hath*
taken away, Blessed be the name of the Lord (Job. 1:21); *I know that my*
Redeemer liveth (Job. 19:25); *In Christ shall all be made alive* (1 Cor.
15:20); *Here we have no continuing city, but we seek one to come* (Heb.
13:14).

Bible Stories

ℰᴑᴃ

Though greedy worms devour my skin and gnaw
My wasting Flesh, Yet God shall build my bones
Again, And clothe them all afresh.
 (Perth Greyfriars)[72]

Considering the wealth of meaningful and prophetic stories in the Bible, it is strange so little is drawn from this source; probably the dislike of representational art following the Reformation had a lingering effect. Two main stories are popular choices, with about 54 stones in my experience showing Adam and Eve and perhaps 10 with Abraham and Isaac. Some of these however are now in such a condition of decay as to be unrecognisable. The best should be given the care and protection afforded to any other national treasure in stone.

Adam and Eve. These nearly all show a delightful interplay between Adam, Eve and the serpent. At Logierait there is a decidedly sexist

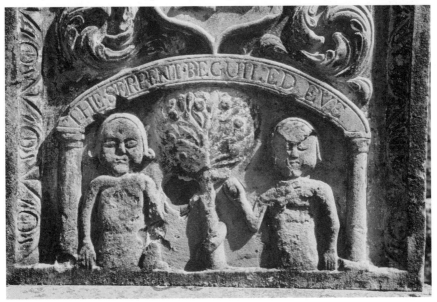

92. One of Logierait's 'Adam and Eve' portrayals.

indication of Eve as the cause of all the trouble![73] Logierait too has the largest and most accessible group of Adam and Eve stones (4) while not so distant Little Dunkeld (the Birnam side of the bridge over the Tay) has two; there's one at Methven, west of Perth, one in Perth Greyfriars, and from Perth on into Angus there are examples at Kinfauns, St Martins, St Madoes, Lundie (Adam and Eve, Abraham and Isaac on the same stone) and Logie Pert. Others in reasonable condition are at Biggar, Polmont, Uphall, Lyne, Dryburgh, there are some in Ayrshire and several in South West Scotland (three at Kells, near New Galloway).

Common to all is a lack of nudity despite this being explicit in the Biblical story, so no big bosom for Eve and handy vegetation to cover for both. At a small, weathered stone at Clachan of Campsie kirkyard and at Logie Pert Adam and Eve do appear naked, but that is following the emphatic Biblical text of Genesis 3:8 (quoted below), nakedness being symbolic of innocence.

The Buchanan Stone at Logie Pert[74] (really North Water Bridge OS 45: 650660) has luxurious flowers shown on it. Each of the figures seems to be about to pluck a rose while, between them, a giant lily has snaked up out of a tiny flowerpot (Carmyllie, Angus, also has flowers growing from a flowerpot, one with a fallen leaf symbolically drifting down). The Campsie stone has references to Job and Genesis on an open book, while the figures stand unhappily before their maker. Genesis 3:8 reads: 'And they heard the voice of the Lord God walking in the garden in the cool of the day and Adam and his wife hid themselves from the presence... And [Adam] said I heard thy voice in the garden, and I was afraid because I was naked and I hid myself. And [God] said Who told thee that thou wast naked. Hast thou eaten of the tree...?'

93. The 'Abraham and Isaac' stone at St Mary's, Grandtully near Aberfeldy.

Abraham and Isaac. Abraham, to prove his devotion and obedience to God, had been commanded by God to sacrifice his son Isaac on

an altar and proceeded to do so. At the last moment there was a divine reprieve – a ram caught by its horns in a thicket which God had provided instead. Isaac was no doubt pleased with the change of plan.[75] Lundie has the most striking portrayal, but even those which are badly weathered have a charm. Other sites worth a look are at Cargill (2), Perth, Methven west of Perth, and Logierait, north of Perth and Grandtully, towards Aberfeldy.

94. *Abernyte's Tree of Life.*

The Sower imagery or *Sower and Reaper* are shown in many places: Ecclesmachan, Colinton and Liberton, Tranent, Fettercairn, Inveresk. In many the figure casts seed from a pannier or from a sack tied round him like a plaid. In some a full sack sits nearby to recharge the sower's bag. Psalm 136:5,6 explains, 'They that sow in tears shall reap in joy. He that goeth forth and weepeth, bearing precious seed, shall doubtless come again with rejoicing, bringing his sheaves with him', thus illustrating the Presbyterian work ethic. But there is also an element of menace behind the imagery: one reaps what one sows. Pencaitland and Corstorphine

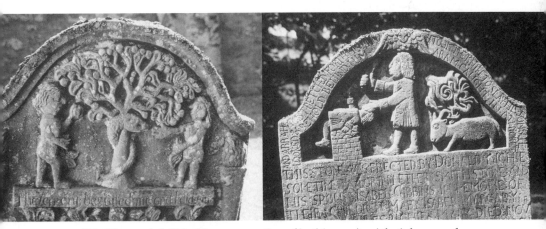

95. *The superb Ritchie stone at Lundie (Angus) with Adam and Eve on one side and Abraham and Isaac on the other.*

have stones with sower/reaper figures. A sower can appear straight-forwardly as part of farming activity, as on the beautiful panel at Liber-ton that shows ploughing, harrowing and sowing.

Tree of Life. This Biblical image (not to be confused with the Tree of Knowledge) is occasionally shown. Willsher mentions depictions at Hoddam (Dumfries) and Stenton (East Lothian) and there's one at Tulliallan on a gardener's stone, where a snake wiggles up into the foliage. On an extraordinarily vivid, almost abstract, stone at Abernyte (Angus) a stem shoots up from a millstone and splits into two curling scrolls over the heads of two figures grasping the stem. They stand, feet turned in, on a band inscribed *Memento Mori*, and a coffin is shown below. There's no other stone like it (*fig. 94*).

The Triumph of Trade

℘)℃ℛ

The following lists most of the trades which have clearly recognised symbols shown on gravestones. They exist from the late seventeenth century, through the eighteenth century and into the early nineteenth century, reflecting the period when the many trade guilds were most powerful and members affluent enough to have gravestones (Guild monopoly was only broken in the 1833 reforms). Sadly, the huge increase in wealth with the industrial revolution saw the Victorians frequently sweeping away these older stones to erect their vast acres of urns, broken pillars, and general swank. Many too have suffered badly

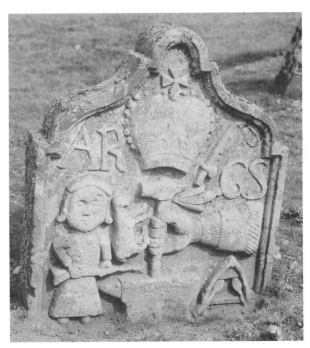

96. This Luncarty stone shows the hammerman's crown with a blacksmith's hand and anvil, the man out with gun and dog, a boat with fish and a fishing rod. An active and prosperous lad, it would appear.

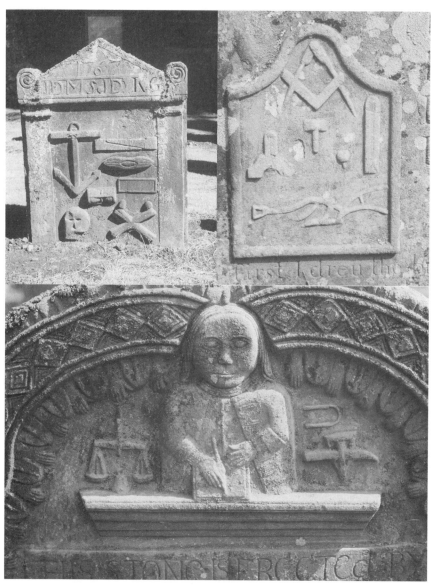

97. Doubling up on trades, combinations seen at Tulliallan (mariner and weaver, top left), Nether St Cyrus (mason and farmer, right) and Monikie (merchant and farmer, below).

from the effects of weather and atmospheric pollution. They are therefore special and precious, as well as showing an aesthetic folk art form which can't but fascinate.

Quite often more than one trade will be shown on a stone, like the merchant/farmer (Monikie), farmer/fisherman (Kirkton of Mailer),

farmer/weaver (Errol), mariner and wright (Tayport), mason/farmer (Nether St Cyrus), farmer and miller (Inverarity). (Examples appear in this section, and *figs. 97* and *116*.)

Symbols of trade gradually disappeared from gravestones in the Victorian era but, up to World War One say, the name of a trade was still often given. A friend sent me this list from a walk round one section of Greyfriars, Perth: flax dealer, tanner, farrier, vintner, slater, mason, wright, plasterer, turner, iron-moulder, brass-finisher, sail manufacturer, cork manufacturer, warper, cabinet maker, many merchants, port master, ship-owner, many innkeepers, letter carrier, collector of poor rates, collector of excise, superintendent of police, city architect, hairdresser, menagerie proprietor, bird stuffer, marble cutter, hosier, hatter, confectioner, druggist, surgeon, teacher of music, artist, tobacconist, army officer and an engineer on *SS Princess* who died of yellow fever in Brazil in 1884.

I've variously noted carriage-builder and cutler (in Edinburgh Canongate), net mender (St Vigeans), steeplejack (see p. 29), toll contractor (Kirkcaldy Abbotshall), book-binder (Kirkcaldy Bennochy), Cork-cutter (Kirkcaldy Old) and Inspector of Highland Roads (Fort William Old). The Howff in Dundee could add chimney sweep, carver and gilder, hacklemaker, soapmaker. Portobello had a salt manufacturer from the Joppa pans.

This habit of noting professions seems largely to have petered out, but one occasionally comes on the unexpected, even today;[76] in recent wanderings I've seen forensic scientist, milk officer, linguist, beadle, lithographer, fireman, classical dancer absoluta, organ builder, radiographer, cartographer, amusement caterer, papermaker, golf club manufacturer and oil rig worker, and in Fife not a few cemeteries have stones depicting a miner's lamp.

The Eighteenth Century Trade Stones

ഇരു

Farmers/Ploughmen. One of the commonest symbols is the *sock* and *coulter* of the plough: the two metal parts of a plough which was otherwise made of wood, and which would go with a ploughman from place to place as he sought engagement (*fig. 98*). The symbol could stand for much more, however: a poorer ploughman's stone – if he had

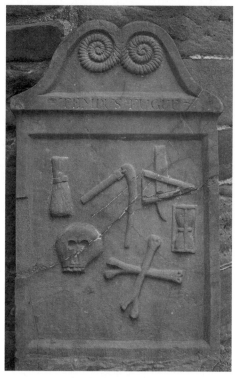

98. The 'sock and coulter' of the farm worker/farmer appears in many styles: heavily emphasised at Torryburn (top left); separately at Murroes (bottom) and at Muthill with several farming symbols.

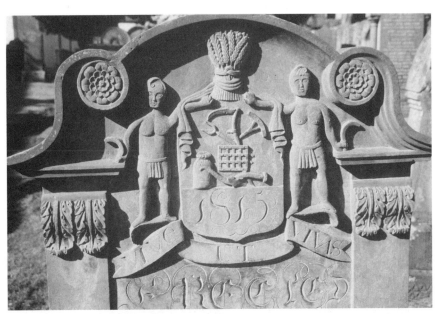

99. *The farmer with it all: sack of grain, plough, harrow, fork, scythe and rake – and some very odd heraldic supporters. (Muthill).*

one at all – might have the symbol and nothing else, not even initials, whereas the symbol might be part of a richly ornate stone, bearing a coat of arms, indicating someone of much greater wealth and standing, a major farmer. The symbol thus could embrace a wide social range and the symbols themselves appear in an endless variety of shapes and sizes, veracity or stylisation. Those at Torryburn are huge (*fig. 98*), those at Clackmannan are often shown with a harrow, and Culross Abbey has about everything possible. Occasionally other items appear: sickle, fork, scythe, flail, corn stook (*fig. 99*). Perthshire north of the Ochils has some sites where sock and coulter are shown separately, and there's one at Murroes (*fig. 98*). Logie Old has a primitive spade, Aberdelgie (Perthshire) a cas chrom (peat cutter). Sock and coulter can also be noted in combination with the symbols of another trade or activity, such as weaver, mason, miller or trader. The predominance of sock and coulter well illustrates the rural nature of life even as the towns and industry were growing and the population balance shifting.

The Carse up into Angus is rich in showing ploughs, double yokes for oxen and swingletrees,[77] with or without horses. (St Maddoes, Inverarity, Carmyllie.) For scenes of ploughing, Colmonel (*fig. 100*) Straiton and Kirkmichael in Ayrshire offer gems, and Liberton (south Edinburgh) has a beautiful panel on a table stone showing ploughing,

100. Ploughing scene at Colmonell, Ayrshire.

harrowing and sowing. Farm animals otherwise are rare (man and horse, cow and calf at Lundie) though Abernyte has several beasts – having a bad time at the butchers. Figures of sowers and reapers are common in East Lothian, others appear at Livingston, the SW and Angus.

Shepherds. The shepherd's crook is the obvious – if rare – symbol, such as at Rhynd, Dunbar and Balmerino (*fig. 101*). At Sorn (Ayrshire) and Old Kilpatrick the figures of a shepherd and his dog are shown.

Gardeners. These interesting stones show the tools used and can range from a simple crossed spade and rake to a splendid array of various

101. Balmerino shepherd's stone.

spade types, rakes, weeding hook, sneading [pruning] knife, shears, twine reel, dibber and watering can – and surprisingly contemporary they appear. Gardeners were employed by people who, at least, would have a fine house, and stones perhaps reflect the social connection. Many gardeners were friends as much as employees. Gardening

102. A neat arranging of gardener's tools at Forgan (near Leuchars, left), a tree-feller at work (Tulliallan, right) and a gamekeeper's stone at Kells (Kirkcudbrightshire, bottom).

was a bit special. There are gems of this calling at Forgan (*fig. 102*), at Auchtermuchty in Fife and in the Howff, Dundee. As mentioned earlier, at Logie Pert and Carmyllie (both Angus) flowers are shown growing in *flowerpots*. At Abercorn the tools are shown between trees with lopped branches (a symbol in itself), at Tulliallan they are below a tree of life with a snake entwined in it. The red-hued Perth Greyfriars gardener's stone (under cover) has Adam and Eve and, with other symbols, a trio of marker flags. Tulliallan's stone for a tree-feller shows a

figure doing just that (*fig. 102*),[78] with the Ecc. 11:3 text 'As the tree falls so must it lie'.

Gamekeepers. Like gardeners, keepers often enjoyed a closer standing than most with their employers, who could own vast estates, and stones can reflect this. They are rare, and the finest example is the well-known stone at Kells, Kirkcudbrightshire (*fig. 102*), a small treasure showing gun, powder flask, fishing rod, partridge and mop-eared dog. The epitaph is also interesting: John was not averse to *snuff, a glass, riddles and noisy mirth*.[79] Willsher notes others at Luncarty and Durisdeer, as well as a *fowler* (Kenmore) and *groom* (Panbridge, Angus). At *Fintry* a farmer's stone shows a man out with his gun and dog, and gun and dog (turned sideways) are squeezed into the ornate stone at Luncarty (*fig. 96*).

Hammermen. One of the commonest symbols in every graveyard is the hammer with a crown above it (*fig. 103*), the symbol of those incorporated in the guild of hammermen. This could cover a huge range of trades, but all were involved, to a greater or lesser extent, with metal. Working iron could lie behind shoeing a horse or replacing a delicate part of a watch. Some other trades that were incorporated were pewterer, glover, goldsmith, saddler, plumber, hookmaker, glazier, cutler, armourer, blacksmith, gunsmith. Tools at a Tranent stone are specifically noted as those of a quaich-maker.[80]

At the heart of their importance lies the fact that some of the guild

103. Guild of hammermen stones: bold and simple (Kirkliston), for a gunsmith (East Wemyss Old) and a smith (Falkland).

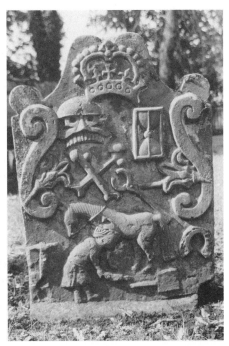

104. Smiths' stones: 'the Hand of God' message at Perth (top left); at work, shoeing a horse at Alloway (right); master and apprentice at work (Rhynd, bottom left).

produced weapons (*fig. 103*), so they had this rare privilege of showing a crown above the hammer. (It was not a unique feature as often stated: the cordiners also show a crown.) Both crown and hammer are shown in endless variety, the crown a simple engraved outline or a three-dimensional extravaganza that would suit a coronation, and the hammer shown vertically, or on its side. Several stones have the elitist couplet: *By hammer and hand / All arts do stand.*

Smiths. This is the commonest of the many crafts with a hammermen's crown appearing, and will have symbols such as an anvil, horseshoe(s), tongs, pincers – any or all of the farrier's tools. Sometimes a hand grasps the hammer above an anvil; in the case of the 1693 Patrick Gow stone in Perth Greyfriars it is specified as the hand of God: *til God hath wrought ws to his wil / the hammer ve shall suffer still*. At Rhynd two smiths (or master and apprentice) wield different sized hammers as they work at an anvil. Alloway has a smith (John Tenment) shoeing a horse (all *fig. 104*). There's a bold crown, hammer and anvil at Abercorn, at Tayport there are two horseshoes shown, at Falkland a particularly neat horseshoe design (*fig. 103*).

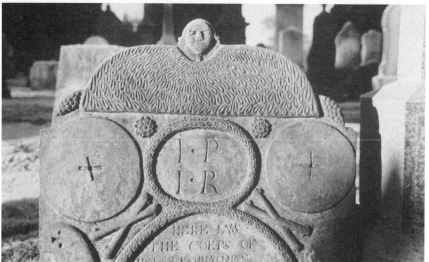

105. Millers: At Kirkmichael some mill machinery is depicted (top left), at Polmont Old (below) both millstones are shown, while the puzzling picture (top right) at least has the indicative rind.

Watchmaker. A unique 1772 stone at Inverarity (next to the church) has beautifully portrayed watchmaker's tools (*fig. 122*). There's also a Pittenweem stone mentioning a watchmaker. I've not met others.

Millers. The commonest indication of a miller will be the symbol of the *rind* (rhynd), the mechanical part which supported the upper

millstone and rested on top of the spindle. They can vary in style and need experience to recognise correctly. Crossed rinds were a *moline*. A millstone or two millstones shown leaves no doubt (*fig. 105*). I was lucky enough to be at St Martins (near Balgeddie) when workmen raised a stone which had long been flat, face down, on which rind, stone and the miller's pick appear as fresh as if newly carved – and a contrast to similar depictions at Methven (on the other side of Perth) where the design is hard to see under a smother of white lichen. Polmont Old (*fig. 105*) has two millstones shown – surmounted by an extraordinary winged spirit. Kirkmichael (Ayrshire) has the best group of several millers' stones, one with a cogged wheel and other bits of mechanism. A miller may also be indicated by showing a sheaf[81] or sheaves of corn with scales or crossed rakes – and these can be confused with maltsters. A millwright could also show a square and compass.

106. *A typical maltster's stone at The Howff, Dundee (left) and maltsters with a barrel of the good stuff, Dalmeny.*

Maltsters. Maltsters (who brewed ale) may or may not show sheaves of corn, but the crossed implements of their trade will be prominent (*fig. 106*): the long-handled shovel, slatted shovel, brush and weedock (a long handled pole with a hook at the end to hold a cleaning cloth).

Until tea and/or coffee worked its way down the class structure, into Victorian times beer was the everyday drink, so stones to maltsmen are not unusual. (St Andrews in the seventeenth century had fifty brewers, for instance.) There is also a chance of confusion with bakers, though their (crossed) paddles are again different. At Dalmeny a couple of figures seem to be 'rolling out the barrel', their high spirits

moderated by a big skull and sexton's tools (*fig. 106*). Maltsmen stones appear in all the big town graveyards.

Salters stones at Tulliallan also have a spade; care is always needed in deciding the trade if spades, peels or paddles are shown.

Merchants. The most obvious symbol of a figure **4** which may occasionally be shown in reverse, ⊁ (*fig. 107*), indicates a merchant, someone who could be a shopkeeper or someone trading to the four corners of the world, which some suggest the **4** indicates. As early as the twelfth century, the **4** was being used to mark trade goods, but it certainly ended up meaning merchant. There is a stone to a famous merchant in Stirling, John Cowane, which has both this symbol and the verbal claim to being a merchant. The stone is dated 1633. (He endowed the nearby hospital; he could afford to, being landlord, town councillor, Dean of Guild, the town's main banker and occasional privateer.) Merchants were often rich, so could indulge in ornate stones. One puzzle is the frequent appearance (among other things) of the letters **M** or **X** at the end of the arms of the **4**; is there a significance?

Some merchants, to show they were honest traders, showed balanced scales on their gravestones, a more popular mark in southern Scotland (*fig. 16*). At Kells (Kirkcudbrightshire) a Father Time figure has tipped down the scales; a different inference. A merchant at Monikie sits smugly writing up his ledger of life while a tiny marginal hand holds scales, this picture balancing a sock and coulter, so he also farmed (*fig. 97*). Another merchant stone (Kirkoswald, Ayrshire), has account book along with inkpot and quill pen (and what look like mermaids). In Kirkcaldy Feuars a merchant has scales, the 4 symbol and a rare indi-

107. The two ways of showing the merchant's symbol: both at Stirling Holy Rude.

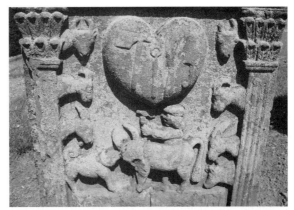
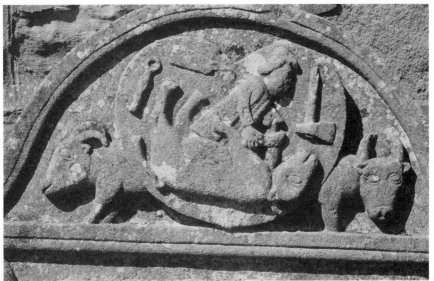

108. Abernyte's butcher pictures: approaching the job (left), stunning a beast being held by his dog (tools shown on the heart, right), and (bottom) beginning to cut up the carcase.

cation of candlemaking – another duality of trades. Stirling Holy Rude has a large number of **4** stones (some the reversed version), and the sign crops up at Tulliallan, Burntisland, West Wemyss, Dundee (The Howff) and Nether St Cyrus – places on the coast where merchants would be investing in overseas ventures.

Fleshers (butchers). The tools of his trade will be indicative: knife (large!), cleaver, axe, steel (sharpener), hooks, skewer and sometimes other additions. In Perth Greyfriars (Table stone in the shelter) and

Abernyte, stones show butchers in uncompromising action; in one a dog clings to a cow's muzzle while the butcher delivers the stunning blow. There's a 1654 stone in St Andrews Cathedral museum showing most of these instruments plus a double yoke for oxen – a farmer named John Vennison. (Oh dear!)

Baxters (bakers). The commonest symbol shows the peels (paddles) on which loaves went in and out the ovens, frequently with small loaves of bread pictured on them, or crossed, or with a scuffle, the pole with a cloth at the end for cleaning the oven (*fig. 109*). Bakers'

stones should not be confused with those of maltsmen, which also show what looks like paddles (but never with loaves). Bakers' stones are not uncommon, so always a pleasure to find. At Abercorn (*fig. 109*) there is the only known stone with the addition of a rolling pin on the design. There are several baxters' stones at Haddington (East Lothian), and Torryburn has peels which are not crossed. A sheaf of corn or scales can also indicate a baker (rather than a miller, farmer or merchant – nobody said recognition was always easy). A baker's van passed me the other day, and I noted it carried the logo of a sheaf of corn.

109. The Abercorn rolling pin and a fine traditional baker's stone at Perth Greyfriars.

Candlemakers. Rare; I only know of two that have survived: one in the Feuars graveyard in Kirkcaldy,[82] the other in Greyfriars, Perth, one of the sheltered stones. Both images are on merchant stones. The candlemakers' frame (I've seen one – in Jerusalem!) or bunch of candles could easily go unrecognised. Only the base remains of a stone at Elie that once showed a farmer-candlemaker combination.

Cordiners (shoemakers) (*fig. 110*) The cordiners were the only guild (besides hammermen) allowed to show a crown, inevitably displayed above their half-moon-shaped cordiner's knife, so they are easy to recognise. The crown can be extremely variable, as with the hammermens', but the cordiner's knife is plain enough. Other instruments can be shown too: various awls, knife, last, rule for taking the size of a foot, shoetree, pliers, etc. In Selkirk and elsewhere the good Scots word *souter* was used rather than cordiner. (Souter Johnnie was immortalised by Burns.) Quite common are comprehensive versions at Lundie and Monikie (Angus), and Roseneath. Having said both cordiners and hammermen alone have a crown, officially anyway, there is one probably naughty use by fishermen at St Vigeans, where a crown surmounts two crossed fishes.

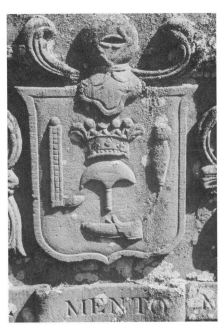

110. Cordiner's stone, Logierait.

Glovers (*fig. 111*). A rare symbol, but there are a few glovers' stones in Perth Greyfriars which are particularly striking: the obvious pair of gloves, shears, buckle, stretchers for fingers might be guessed at, but what of the "dangling balls" as I heard them called? The 'balls' are bells, the sort of thing seen on the costumes of

111. Glover's stone; Perth Greyfriars.

Morris dancers – one of which is held by the Perth museum. There's a glover's stone at Clackmannan and the words on p. 12 come from a glover's stone at Elgin (see note 10).

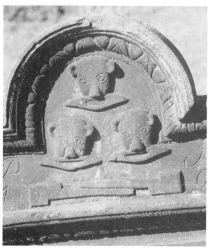
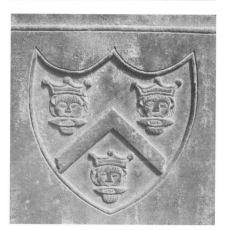

112. Weavers' stones (clockwise from top left): a shuttle alone (For-gan), a weaver at work (Monikie), the crowned heads with shuttles in mouth (The Howff, Dundee) and the animal heads with shuttles in mouth (Kirkcaldy Feuars).

Weavers (*fig. 112*). One of the most frequently met symbols, reflecting the large number of people who were once engaged in this home industry, is the shuttle, sometimes with the carding comb, stretchers, etc. A weaver could in fact be running a combine and be a relatively wealthy person. Power looms and advanced technology (Spinning Jenny and all that) would see the industry move to factory production, so individual

stones faded out. Weaving was also a trade that might be combined with other activities and a stone might show a ship and shuttle as at Tulliallan (Kincardine) on the Forth Estuary. (Someone possibly traded with the Baltic, and when the ports froze up would turn to weaving.) The shuttle and the loom itself appear on some stones, and looms with a figure sitting at work can be seen at Forgan (NE Fife), and also at Auchterhouse and Monikie (Angus), while a shuttle alone must be one of the commonest of symbols.

At Kirkcaldy Feuars, Perth Greyfriars and elsewhere there are strange images of shuttles held in the mouths of three cat-like beasts, sometimes called leopards or panthers, the meaning behind this symbolism unknown. Falkland and Aberfoyle have a shuttle in the mouth of a single cat creature. At Inverarity and the Howff (Dundee) three crowned human heads hold the shuttles in their mouths (*fig. 112*).[83] Some of the language of weaving however has entered life generally: warp and woof, stretchers, tenderhooks...

Tailors (*fig. 113*). Tailors inevitably have scissors (shears) and an iron (goose) shown on their stones, arranged in a wide variety of styles. More complex stones might also show needle (bodkin), reel (bobbin), ball of yarn, pressing board and stay poker. Such stones are not rare; there are fine examples at Monikie, St Maddoes and Monifieth (all in Angus).

Dyers. This became a separate trade from weaving as the eighteenth century progressed (as was bleaching). Home production simply could

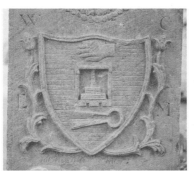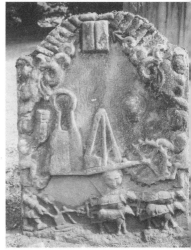

113. *Tailor's symbols on a stone at Murroes, a dyer's stone, Perth Greyfriars, and a waulkmiller at Kirkmichael (Ayrshire).*

not meet demand for cloth. Only the specialised tweed industry in the Hebrides would make it into recent times, the gentle colours coming from natural dyes. There's a fine dyer's stone in Perth Greyfriars (*fig. 113*) with a shield showing glove, press and tongs; another at Strathmiglo.

Waulkmillers. These are rare and can be confused with dyers (with their broad shears taken for tongs, say) but the fuller's pot will be diagnostic. Cleaning, softening and shrinking cloth again lingered longest with the tweed industry in the Outer Hebrides, where groups of girls would work at a table singing rhythmic waulking songs. In a rare depiction at Kirkmichael (*fig. 113*) the miller holds up an hourglass beside giant shears, while his assistant (journeyman) operates the machinery. The fuller's pot is shown above this scene while below is a picture of ploughing (the miller rather heavy on the ploughman!), a man with a whip assisting – a scene on several stones in this kirkyard and at Alloway and Colmonell, one or two of which have the Biblical text, 'No man, having put his hand to the plough and looking back, is fit for the kingdom of God' (Luke 9:62). Very much of the local Ayrshire style are the busted figures with serpent tails and arrowhead stings that adorn the top of the Kirkmichael stone.

Masons (*fig. 115*). This can be more complex. Their tools are normally indicative, but the main items shown, hammer and chisels, could also be used by *quarrymen* or *miners* (*fig. 114*) so care is needed to differentiate. The masons also had the symbol, often heraldically shown, of three castles. Sometimes several types of chisel may be shown with

114. Tulliallan: a stone for a collier (miner).

mell, wedges, level, plumb line, square and compass. There's a *quarryman's* stone at Muiravonside (west of Linlithgow, by the Union Canal) which shows their different pick, and Pencaitland adds crowbars to an array of tools, which could equally be for a *miner*. Very rarely the coal-master's compass (used underground) is portrayed. *Slaters* can be confusingly similar but may have the traditional slater's knife.

Masons, by their very skills, often made highly ornate stones for their spouses, or themselves, which may

have little to indicate they were masons. *Fig. 122* (centre) looks more like a cheese press till the eagle is seen to be perched on two chisels and a mell and the large rectangle that had once held the inscription.

Masons, in the sense of being freemasons, have symbols of stars, sun, moon, etc as well as the regular crossed compass and square. There's a good example in Kirkcaldy Old and on the Methven Adam and Eve stone. The reverse of this shows John Watt naming a son John (who died at 6 months), then another son John, (who died aged eighteen

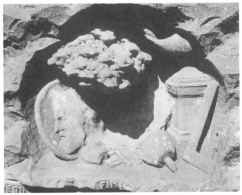

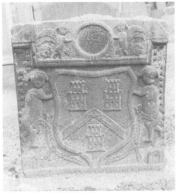

115. Classy examples of masons' work: Errol, tools (top), Kirkcaldy Abbotshall, a three dimensional effort (bottom left) and Polmont Old, (bottom right) with the heraldic three castles of the guild.

116. *A wright's stone at Kinnoul, Perth (left), and one at Inverarity, where he was a farmer as well.*

months). *Hands clasped* are not a masonic indication but may be from one of the Friendly Societies that flourished in bygone days. They are not uncommon. There are two at Beath, one at Dollar, one at Meigle.

Wrights (*Carpenters*) (*fig. 116*). Their stones usually show an array of appropriate tools, the more the easier to identify the trade (a square and compass, for instance, could equally be indicating a mason). Others are saw, level, rule, axe, pliers, hammer, plane. *Cartwrights* and *Wheelrights* likewise were incorporated. All used wood. But then so did *Coopers* and *Slaters* who, confusingly, could show somewhat different hammers. (The short hammer – and dividers – are clear on a cooper's stone at Kettins near Coupar Angus. Their draw knife can also appear.) *Millwrights* would always show a rind.

Shipwrights/Shipbuilders (*fig. 117*). An extension of the carpenter, but some different tools are likely to be shown, like hatchet, auger, caulking tools or just the simple adze with which a lot of their work was done. A ship shown without sails or as a hull only indicates a shipbuilder. Tulliallan (Kincardine on Forth) has several examples, and the finest is in Montrose Old (south part – *fig. 117*). At Kirkcaldy Old there is a five foot high stone which is in the shape of a ship's hull, bow skywards.

Shipowners, shipmasters. One of the most delightful symbols, and happily fairly common, is of ships which can be everything from small coastal trading craft to stately ocean-going vessels (*fig. 118*). Shipmasters are also represented by navigational instruments: sextant, astrolabe, quadrant, cross-staff, compass, dividers – copies in stone of

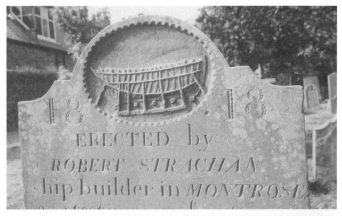

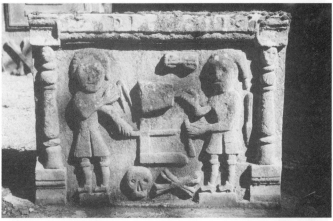

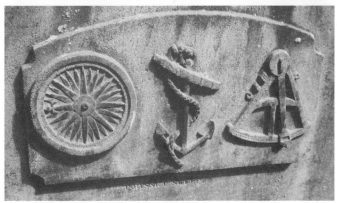

117. A detailed shipbuilder's stone at Montrose (top), a shipwright and apprentice at work (Tulliallan, middle) and typical mariner's instruments in The Howff, Dundee (anchor between compass and sextant, bottom).

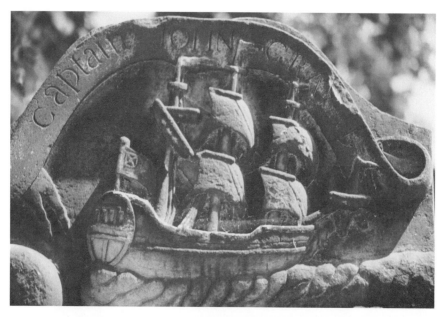

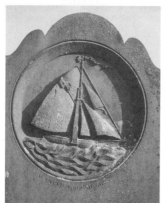
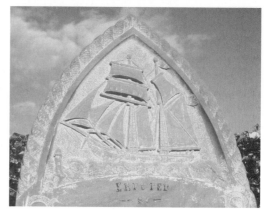

118. Ships appear in many sizes and shapes; these can be seen at Edinburgh Calton Old (top), Scoonie (Leven, bottom left) and Kirkmaiden (bottom right).

similar instruments in paintings seen on the balconies of Burntisland church. Examples of the instruments can be found at Dalmeny, Torryburn, Tulliallan, Dalmeny, Aberlady (also a globe) and The Howff in Dundee (*fig. 117*). An *anchor* is perhaps the commonest, and longest-running, symbol for anyone who had, or has, dealings with sea and ships. Religious symbolism has an anchor pointing *up* – anchored in heaven. A fouled anchor (one entwined with rope or chain) usually

infers a one time Royal Naval career and, on its side, may mean death occurred at sea, but anchors were often used (and still are) with little knowledge of such traditions.

The finest collection of sea-going craft on gravestones is probably at Tulliallan (Kincardine) on the upper Forth estuary. Almost certainly the ships shown are portraits rather than symbols: these were the gravestones of proud builders and owners and captains, and the details are precise. It is interesting, occasionally, to find sails and flags apparently blowing in opposite directions; not an error, but showing the ship is sailing close to the wind!

There are fine individual sailing ships to be spotted in Greyfriars (Perth), Queensferry (south shore of the Forth), Larbert Old, Scoonie (Leven), Bothkennar (Skinflats), Montrose and many others – finding such always a serendipitous joy.

Fishermen. Fishermen were never as organised as other guilds, their living far too dependent on weather and tides. Burntisland church has an outside stair leading to a fishermen's balcony so, if conditions dictated, they could slip away quietly. (The tides were God's affair after all; no other trade had such liberty.) There are stones with fish at St Vigeans (Angus) and several fish/boats appear at Rhynd, a lonely spot where the River Earn joins the Tay (OS 58:183185). In the old churchyard at East Wemyss all the fishermen portray anchors on their stones. The

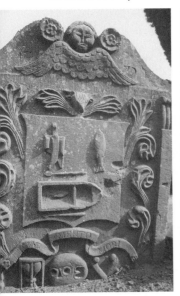

119. A fisherman's stone at Kinfauns above the River Tay – a farmer as well (left) and a ferryman's stone at Rhynd.

small graveyard at Kirkton of Mailer has fish lying in a boat too and a larger depiction of a salmon (OS 58: 110201). One of the salmon netters was also a weaver. At Banchory Devenick a hand holds a salmon with a net behind (he is called a laxfisher).

Ferrymen. I only know of the three ferrymen depictions at Kinnoull on the north bank of the Tay in Perth itself (one nearly buried) and a boat being poled on the sea at Rhynd, a natural place for a ferry as it lies where the River Earn joins the Tay (*fig. 119*). Two men in a small boat on top of a stone at Rossie Island could be crossing the entrance to Montrose Basin (in days before there was a bridge).

Ropemaker. I've only seen one stone indicating this trade, at Tulliallan unsurprisingly, with its nautical connections. It shows a short section of rope and the feeder mechanism for making the twist in the rope. Another stone has a circle of rope round an hourglass as its main decoration.

Salter. Tulliallan again, the bigger shovel indicative.

The sea image is used for an eleven year old boy's epitaph on a 1756 stone at Forgan (E Fife): '*Tho Boreas and Nepto / His waves hath tossed / Me to and fro Yet by / the order of God's de /cree I harbourr here /below where now I ly / at anchor sure with many / of owre fleet expecting / one day to set sail my /admiral Christ to meet.* (There are many variants of this epitaph;[84] I suspect the odd line splitting of this version was to gain neater symmetry.)

120. *The surgeon-barber's symbols, Alloa Greenside.*

Surgeon/Barber. Medicine before the mid-eighteenth century had hardly changed in a thousand years, people lived in dirty, unclean conditions (even the wealthy; a painting of the murder of Thomas à Becket when cleaned showed that what was thought to be a stream of blood flowing from the corpse was actually all the beasties leaving the cold body). There were no defences against contagious diseases, half of children born would not reach adulthood, anaesthetics were unknown, superstition rife and

many practices anything but helpful, including the common belief in bleeding a patient, usually the task of the barber or, more pretentiously, a surgeon. I've only seen one stone showing a bleeding bowl, in Alloa Greenside (Clackmannanshire – graveyard key from nearby council offices: *fig. 120*).

When medical knowledge improved in the eighteenth century, the surgeons went on to form a grander medical fraternity, and the barbers, with less to do medically, were also the century's *wig makers*. A wig stand, combs, etc, can be seen in Perth Greyfriars.[85] A survival from those times is the barber's pole with its blue and red striped pattern standing for the venous and arterial blood; I wonder how many of today's hairdressers know that.

Schoolmasters. Stones to teachers are not too common. At times teachers could be barely literate themselves, but others rendered great service, which is noted in words rather than pictorially. Willsher describes their often difficult conditions. In West Wemyss there's a stone raised for a teacher who taught there for nearly fifty years. He was also a bone setter, another example of dual skills. There are two, one rather special, at Auchterhouse,[86] and at Carrington and elsewhere the figure holding a book is a teacher.

Military. At the start of the eighteenth century military stones tended to have fairly ordinary stones, their doings in douce words, but as the century advanced and even more so once 'Great Britain' had an empire to rule there was a demand for visible patriotic symbols. While the wall tablet VC at St Martins may be modest, there would soon be the 'grand' monument like Inveresk (*fig. 62*). The Carriden Admiral of the Fleet had his extensive lair marked off with chains which came from a warship. World War One was so awful that the outpouring of monuments for its dead tended to be general, not individual, and wreaths are still laid each 11 November. At Loch Leven (Kinross) there is a gravestone to an eighteen-year-old 2nd Lieutenant in the then new Royal Flying Corps, killed while flying in 1918, *Dulce et decorum est pro patria mori*[87] inscribed on it.

But to return to the eighteenth century, soldiering might only be part of a man's life, and there was still much to contribute as a civilian again. (Much as today when you think of it.) At Liberton (Edinburgh) there's a 1737 quotable stone illustrating this: *Here lies entombed within this vault so dark, / A tailor, cloth-drawer, soldier, parish clerk, / Death snatched him hence, and also from him took / His needle, thimble, sword and prayer book...*

> *Here lies removed from mundane scenes,*
> *A major of the King's Marines,*
> *Under arrest in narrow borders*
> *He rises not till further orders.*

Minister. Often ministers are shown holding a book, presumably the Bible, as at Fintry (*fig. 91*) or with one lying beside them, as at Auchtertool. Holding a book was a favourite image south of the Forth: see Lilliesleaf (inside the ruin), Newbattle and West Linton, though these may not be to reverend gentlemen (wording can't be made out). At Barr (Ayrshire) a rather forlorn minister figure is shown perched in

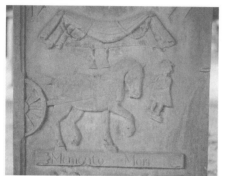

121. Carrier (Perth Greyfriars, top left), Packman (Isle of Mull, top right), Cadger (Burntisland).

his pulpit, neckbands clear – but the worn stone leans on another and is hard to spot. Figures lying down while reading a book appear in southern Scotland (Newbattle, Dumfries) and St Michael's, Dumfries, has the book specifically noted as being *the word of God*.

Tinker. Mentioned under 'Ageism', the Kirkcudbright stone is probably unique (*fig. 44 r.*).

Carter, Cadger, Packman (*fig. 121*). *Carters* (carriers) moved heavier items and produce from place to place and between rural and urban settlements, so the few stones are a delight with the big old horses and carts portrayed. Perth Greyfriars (under the cover) and St Madoes are examples. A *cadger* would at most have a barrow and moved goods, almost anything, locally. Burntisland has a monument to cadger John Arnot, showing the dwarfish, barefoot, bunneted figure pushing a barrow. Not quite mentally balanced, he had a phenomenal memory and could, for instance, remember the minister's lengthy sermon word for word. He made use of this talent by visiting the old, sick and housebound to repeat the sermon during the week. (I wonder just how much this was appreciated!) Arnot came to an unhappy end, for he died when student pranksters put snuff in his beer.

The only *packman* grave I've seen is up the River Lussa in Mull.

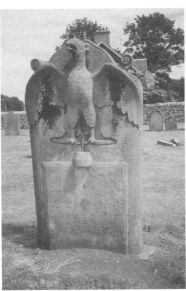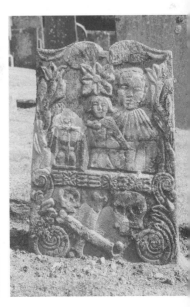

122. Classic stones (left to right): watchmaker's tools (Inverarity), an eagle dominating a mason's stone at Dalmeny and skilled work on a stone at Barr.

John Jones had stayed to nurse a dying couple with smallpox before moving on but, having caught the disease, died in this lonely spot. When discovered, such was the fear of infection, he was buried on the spot, pack and all.

123. Spot the nautical pun.[88]

The Present Plastic Age

ഔ

A Highlander many years ago saw the Tomnahurich burial ground above Inverness and thought it "wondrous beautiful". He declared, "This is where I want to be buried – if I'm spared".

Every now and then, when wandering the stony ranks of Victorian graveyards, eyes light on something special: a beautiful script, a simple design, a factual curiosity or even something startlingly different. My reaction being the same wandering round a graveyard or cemetery in use today, I realised just how little has changed. Practically every aspect of Victoriana is reproduced today, including the ostentation and sentimentality.

Sites today tend to be less attractive; with old graveyards filling up, cemeteries are often opened simply as and where authorities can manage, not always by expanding from an older location, and the layout can prove rather regimented. The least interesting period, visually, has

124. A loving modern stone for a lost child.

to be from post World War Two to the seventies, when ranks of grey granite reflect the austerity years. But people don't change, our feelings at the loss of loved ones are as strong as ever, in some ways more desperately so in an age of unbelief and uncertainty.

Life is still a risky business and, if we have lost the horrors of high infant mortality and devastating epidemics, there are still many stones recording the deaths of children and young people. These are instantly noticed, often with unusual stones and an abundance of plastic toys, plastic angels, plastic flowers (*fig. 124*). Even the stones today have a plastic appearance, the unreal black shiny marble (from India as like as not) with unfading gilt lettering. In my youth a frequent source of pocket money was finding glass lemonade bottles and reclaiming the sixpenny deposits. I was very conscious of when that changed and bottles became throw-away plastic. While others suggested 'Atomic Age' or 'Elizabethan Age' I declared the dawn of a 'Plastic Age', and so it is, from cradle to grave. This is simply an observation, not a criticism, an awareness of the fascinating progression through decades and centuries, brought up to date.

The symbols today have not so much changed as proliferated and, whether something chosen from an undertaker's sample book or something original, they offer a great 'compare and contrast'

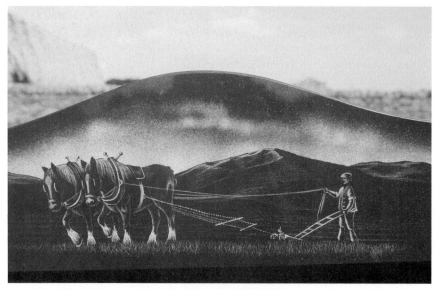

125. The delicacy possible today in a ploughing scene, one of many at Tealing.

game with past customs.[89] In rural Angus the picture of ploughing with horses is a favourite (*fig. 125*), though I'm sure half the people choosing such have only ever sat on a tractor. I've seen tractors too portrayed on stones, and a steam engine, crane, a range of cars, trains, lorries, motorbikes (classic/sidecars/new), caravan, stock car racer, mountain bikes, wheelchair, many fishing boats at coastal sites, even a spaceship.

Sport is well represented and, besides the dominance of fishing, golf[90] and football (*fig. 126*) I've noted climbing, abseiling, skiing, tennis, sailing, bowls, darts, karting, basketball, bodybuilding. Pastimes include dyking, gardening, riding, show jumping, horse racing, shooting, skating, harecoursing, tropical fish. Music is well represented, with guitar, violin, accordion, mouth organ, trumpet, drums, trombone and bagpipes – and sometimes a bar or two of a song. I've a picture of a senior couple obviously enjoying a dance together – and an accurate rendering of the record sleeve of *The Sound of Music* (*fig. 127*). An old lady sits knitting in her armchair, cat on lap...

126. *Footballer, Tullibody.*

127. *Did they know the singalong version, I wonder?*

There are flowers galore, of recognisable species (bluebell, primrose, lily of the valley, pansy, snowdrop etc) besides a regular nationalistic showing of thistle, rose and shamrock (why no leek?). Robins, blue tits, swallows, doves, swans and other birds appear, portraits obviously of pet dogs and cats, and horses, stags and butterflies.

Badges with all sorts of associations are shown, from Scouts or BBs

128. A trade is occasionally shown today, like this miner's lamp at Beith.

to a range of recognisable military ones. Miners' lamps (*fig. 128*), firemen's gear or a blacksmith at work are very much in the older tradition of depicting trades.

There are obvious pictures of homes, or views from home (eg Sidlaw Hills) with recognisable scenery, or copybook icons like the Wallace Monument or the Forth Bridge. I've one scene with a wine bottle and can of IRN-BRU, Scotland's other national drink.

Children's stones have an endless range of teddy bears (even the stone can be bear-shaped), sporting emblems (footballs usually), and figures from books and even Bart Simpson (*fig. 129*) – besides all the plastic accumulation of figurines, souvenirs, toys, actual teddies, knick-knacks, whirlygigs and wind chimes.

Much of this has only become possible with modern technology. People can choose lettering and artwork at a funeral company, fine-tuning requirements on computer and leaving it to be transferred to the chosen stone, granite the most likely. Many colours of granite are available (some very costly) with black the most popular, a granite most often imported from India. All can be polished to a smoothness impossible previously and thus are able to take lettering that will last, mostly gold leaf. A template is made gravestone-size and the lettering is blasted out, not cut. Again, thanks to computers, the most delicate drawings can be transferred, with the range mentioned above simply some I've seen recently; a book of patterns at an undertaker's can have hundreds of suggestions.

129. TV's influence on a Kirkcaldy Hayfield stone.

There is a far bigger range of symbols and emblems (call them what you will) now than in any past age. My ultimate disbelief was at seeing this *fly* (*fig. 130*)!

Flowery epitaphs seem to be a thing of the past, but brief rhymes that would do McGonagall proud proliferate, and in newspaper 'In Memoriam' columns reach epidemic proportions. Here are a few I've most recently gleaned,[91] some no doubt original, others from copy books.

130. At Tayport New. Why?

You fell asleep without goodbye / But our love for you / Will never die / Night night Daddy, my shining star.

There is a beaming star / That shimmers from above / I know it is my Auntie Annie / Sending me her love.

A tiny little moonbeam /That danced inside our hearts / A little life has been taken / Before it even starts.

Please find your softest / pillow Lord, to rest his / head upon, and place a / kiss upon his cheek / and tell him who its from.

If tears could make / a stairway / Memories a lane / we would climb right / up to Heaven / and bring you / home again.

131. Examples of eye-catching modern stones from Logie, Cupar Old and Lanark.

132. The stylish crematoria addition to Tayport New Cemetery.

A recent phenomenon is the allocation of certain areas within cemeteries for interring ashes from crematoria. Given minimal space, the effect is strange, and from the air must resemble some colourful carpet patterned in squares. In some areas a tasteful repository system has been created, like the one shown (*fig. 132*) at Tayport New with its view over the estuary to the bridges and Dundee. (But I'm still going for my ashes being scattered on Rannoch Moor!)

> *Thro life what cares and ills molest*
> *Alternate rounds of joy and fear*
> *The weary wanderer hopes for rest*
> *And seeks it there but finds it here.*
> (Larbert Old)

An Appeal

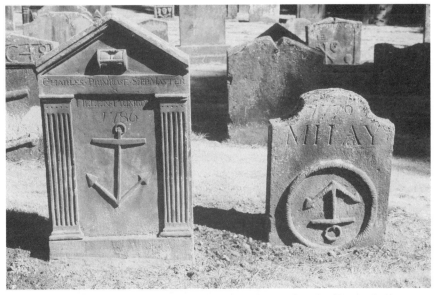

133. Immaculate Tulliallan. The right anchor indicates being anchored above!

Following the Reformation, stone – and gravestones – from St Andrews' Cathedral were pillaged to build town houses. In 1659 Cromwell pillaged gravestones from Perth's Greyfriars to build his citadel on the South Inch, the Victorians often cleared old graveyards to reuse them for burials, today stones may disappear to make room for a car park or bacause of worries about safety.

At the risk of some repetition I'd like to make something of an appeal to close. One would think graveyards and cemeteries would be safe from such misuse but, alas, they too often reflect their location and can also be a favourite place for youngsters (and the not so young) to resort to with booze and drugs, the influence of which so often leads to mindless vandalism. (Pushing over gravestones is fun!)

And all too easy, because of the bad practices of local authorities who regularly undermine stones by cutting back the grass to make

134. The captive Buchanan Stone at Logie Pert.

mowing easier. I often come on remedial work being carried out with stones being given new foundations, but this tends to be more with post-World War Two stones than with our real treasures. Since I photographed Kirkcaldy's unique table stone (*fig. 23*) cheap safety measures have laid it flat and the legs have seemingly gone to a tip. The Buchanan stone (Logie Pert) is of national importance, yet sits west of a busy road with its pollution, and one face is impossible to study freely as iron railings are slap up against it (*fig. 134*).

Surely stones of this standing should be replaced by replicas (like many Pictish symbol stones) and removed to conditions which will guarantee their preservation and conservation. A museum of our best eighteenth century gravestones would be a winner.

Sadly, for much of my lifetime we have had governments who have singularly refused to invest in people's culture or happiness (the two can't be separated) and then have had to spend vastly greater sums than any saved on salvaging unhappy lives from the human wreckage. Such blinkered policy-making sees local government and conservation bodies screwed in turn, so old gravestones are very low on the list of how budgets should be spent. Local government *has to* maintain grave-yards and cemeteries, but it is much easier to lock an old graveyard and pin a 'Keep Out' sign on its rusting gate than finance any restoration – or simply to flatten stones 'for safety' (Edinburgh City Council). Yet the more attractive a graveyard is, the less likely it is to suffer vandalism (moronic damage is never done publicly!)

The biggest problem is that stones/plots *belong* to someone; this may mean a caring contemporary family, but it could also mean per-sons unknown who emigrated to Brisbane two centuries ago. In any not entirely contemporary graveyard the vast majority of stones have no known ownership, yet local authorities are loathe to risk doing any-thing about them. Their hands are tied. Willy-nilly, when they do have to act, all too often it is negatively, so it is not uncommon to see a heap of broken Victoriana pushed to some corner or, as in that gem of a site, Culross Old West, see a pile of junked classic eighteenth century

stones – which were of historic interest. My concern, and that of many others, is for these older stones with their brilliant folk art, the material described and illustrated in Part Two of this book.

At Collace there is an Adam and Eve stone, a small end panel off a table stone lying flat on the ground, its original place unknown, unprotected. To try and record it, at least, I took photographs; in doing so I brushed some cobwebs aside, and was horrified to see a portion flake off. The sandstone block is now no more than loose laminations, and *almost* beyond saving. Why has it been allowed to reach such a state? We look after everything from prehistoric heaps of stone to mighty castles, but somehow this Scotland-wide treasure has been neglected.

There is a crying need, then, for introducing legislation that will allow stones, of say, pre World War One vintage with no known claims of ownership, or a neglected ownership, to be taken into care.

If you see the beauty of these old stones, do please write to our Scottish Executive, or your MSP, and put the case for such legislation. The hard stone of bureaucracy can be changed by the drip-drip of public opinion.

Doing anything is difficult, but why are congregations of churches with superb graveyards so ineffective? Why are so many local authorities still causing problems rather than solving them? We need this sort of legislation to gain freedom of action. We have had initiative strangled with OTT rules and regulations and fears of litigation, but it can be

135. Restoration work: St Michael's (East Perthshire).

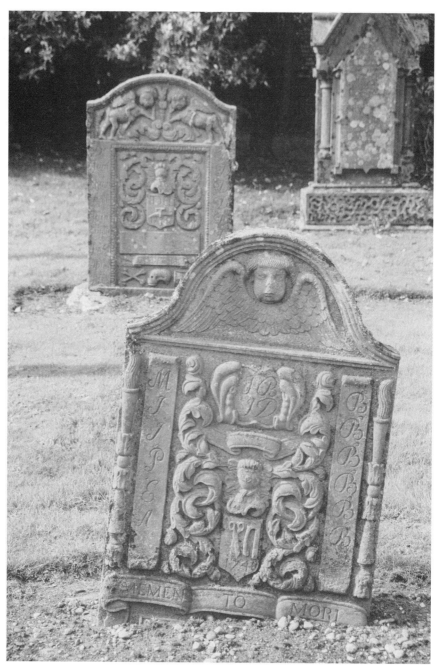

136. Edzell, rewarding with good care and maintenance.

done. Visit (and suggest, in any propaganda, that others visit) the marvellous graveyard at Tulliallan (Kincardine) which has been restored by a group of enthusiasts who overcame all the problems. It was done.

Stones I visited forty years ago have noticeably degenerated since, some more so than in all the centuries since they were created. Any remedial work takes a painfully long time, which is why I would appeal, NOW, for readers to play their part in saving Adam and Eve and all their precious graveyard progeny.

Appendices

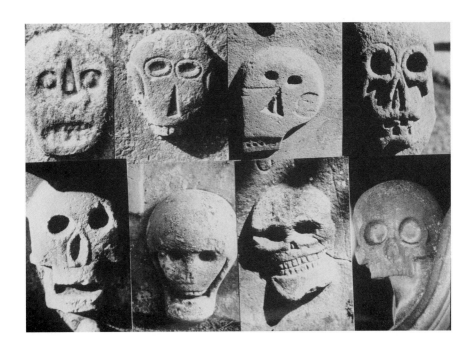

Location of Some Favourite Graveyards
ℰᗰ¢ℛ

This is a very personal selection, but does indicate some of the richest sources, in order from the far south west, Ayrshire, Borders, Lothian, Fife and on to Angus, a great swathe which is within easy reach of the majority of Scotland's population. Willsher, in *Stones*, indexes 177 sites and lists a supplementary 49 also worth seeing. Get going!

Kirkcudbright (OS83: 692512). An attractive site up above the town (B727) with the best stones on or below a steep bank. Many table stones, one with exquisitely decorated legs, and the 120-year-old tinker's stone (search right in the middle of the flat area for it).

Kells (near New Galloway. OS77: 632784). Full of good things: Adam and Eve (2), lots of fine carvings and symbols and the famous small gamekeeper's stone.

Crowdieknowe (west of Langholm. OS79: 257802). This was a serendipity site for me. Rich red stones with a lot of interesting features. A delightful setting and presumably known to Hugh McDiarmid!

Ayrshire. Barr (OS76: 275942). Ayrshire has many sites with a few gems, but the attractive village of Barr has a real treasure trove, with several Covenanters' stones and the picture of a minister in a pulpit. There is a booklet describing the graveyard. Not too far off is *Clonmonell* (OS74: 145857), which has the scene of oxen ploughing, *Kirkoswald* (OS70: 239075), which is full of Burns associations and a whole range of interests, including the 'mermaid' speciality of Ayrshire. (Girvan ditto.) *Kirkmichael* (OS70: 345089), *Alloway* (OS70: 332181 opposite the smart parish church) has Burns' father and some Father Time/skeleton stones and a blacksmith shoeing a horse. *Kirkmichael* (OS70: 345089) has the best collection of scenes of ploughing, the interesting waulkmiller stone, and several millers' stones showing figures and/or machinery.

Peebles (OS73: 245406). On the A72 road west. As the town is left the graveyard lies on the right, with a prominent old tower. There's a rich variety of stones, some very decorative, some suggesting the work of one mason. An attractive setting. *Stobo* and *Lyne* (OS72: 191405) are nearby, the latter having an Adam and Eve stone (behind a Perspex cover). *Stobo* (OS72: 182376) on the B712, which runs from near Peebles to the A701: this delightful setting and old church has an unusual number of skeletons. A stone to a group of three sisters a gem. Jougs by the door.

West Linton (OS72: 149516). Off the A702 Edinburgh-Biggar road, at the far end of the attractive village. A good variety of topics, including several good period costumes. Props popular. Bee boles in a wall.

Muiravonside (west of Linlithgow. OS65: 956769). Beside the Union Canal, several fine eighteenth century stones, angel trumpeters, figures on edge of stones. Above lies a huge modern graveyard.

Dalmeny (OS65: 144775). Fine Romanesque church. Stone coffin by the door. Boldly made stones, including a huge eagle, and maltsters 'rolling out the barrel'.

Edinburgh. Dean (OS66: 236739). There's a gate from the Dean Art Gallery car park into this colossal exhibition of Victorian practice. Edinburgh's wise and good in plenty: Cockburn, Jeffrey, Playfair, Thomas Bouch, Stuart Blackie, Elsie Ingles, Isabella Bird, Professor J.D. Forbes, Dr Bell, Noel Paton, Sam Bough, Patrick Nasmyth, Fighting Mac and military in abundance. *Liberton* (south side of Edinburgh, off A701; OS66: 215692) A table stone with exquisite farming scenes, skeletons, a horrific face and plenty else make this the best of the city's graveyards round a church. *Corstorphine* (OS66: 200728) has the notable Father Time figure and other interesting stones. *Craigentinny Marbles* (OS66: 291744) Surprisingly unknown, an astonishing sight.

Haddington (OS66: 518736). Repays careful study, with a sample of many subjects. Bread on baker's paddles on a table stone. Big church and an attractive town. *Pencaitland* (OS66: 440685) has a notable rural ploughing scene and an abundance of figures and curiosities. With *Tranent* (OS66: 403734) the best sites in East Lothian.

Stirling, Holy Rude (near Stirling Castle). A 'top three' choice. Graveyards have spread from the Holy Rude church right up to near the castle, an impressive array, and one of the most scenic graveyards in Scotland. Old part full of interest. Many **4** and **⚓** stones. Many notable

figures of Scottish reformers and covenanting associations, including the huge Star Pyramid and Martyrs' memorial. The Museum below sells a guidebook to some of the site's notable persons. Photographers will want both morning *and* afternoon light. Park at museum and walk up.

Tullibody (On Menstrie road. OS58: 860956). An overlooked treasure collection of stones, all with simple linear designs that Picasso would have loved. Morning best for photography. *Old Logie Kirk* (Near Wallace Monument. OS57: 815970) Up past the modern church/cemetery, an atmospheric place with some interesting stones, including one well-preserved flat stone with many symbols, a large spade and much to interest. Good brambling spot!

Clackmannan (OS58: 909916). Town, church and graveyard a pleasant whole. Many *sock and coulter* stones and styles of stones unlike anywhere else. The north side has a large number of low, kerb-like stones, covering several *breids*.

Queensferry Old (south side of the Forth, OS65: 132782). Key from the Council offices, a few minutes walk away. Nautical interests (superb ship under sail) and a group of entertaining trumpeters. Skulls aplenty. Bee boles.

Tulliallan (Kincardine, OS65: 933880). A 'top three' choice. Carefully restored, all stones clean and erect, this is a model of what can be done. The site is a treasure trove with many trades shown, and particularly rich in portraying ships and everything nautical. Locked, but key, and guide, available at the Coffee House at the corner when turning off at the central traffic lights. The graveyard lies up past the three obvious tower blocks. Good both morning and afternoon.

Culross (OS65: 988863). A rich haul of stones showing most subjects, with nearly all the carving facing west. Don't miss the Bruce Aisle inside the Abbey church – parents as standard marble effigies, but their three sons and five daughters kneeling dressed in contemporary fashions. *Culross West* (OS65: 979865) is also of interest. Walk to it, tarmac only goes so far, then farm track. Church ruin lintels have older stones re-used. A surprisingly good variety of stones and a delightful spot. From the abbey turn inland and, shortly, left, take field-edge path, cross a road, track on to T-junction, right, then left at Y-fork. Culross is covered in my *25 Walks, Fife* (Mercat Press).

Auchtermuchty (OS58: 239116). A great range of interests. Fine gardener's stone, range of topics, Henry Brown, and Tay Bridge disaster stones. *Forgan* (off Leuchars-Tayport road, B945. OS59: 445259). One of the finest ranges of stones, some delicate work, costumes, weavers at work, gardener's stone and much else. Superb spot. *Tayport* (Ferry port on Craig, OS59: 459286). A fine choice of delicate classic revival stones. Nautical interests. Mornings best for pictures.

Logierait (OS53: 967520). Off the A9 about 26 miles north of Perth, turning west at Ballinluig. Adam and Eve stones, Abraham and Isaac, ornate stones aplenty, trio of mortsafe cages – small area, concentrated riches. *St Mary's, Grandtully* (OS53: 886506) not far off with an outstanding Abraham and Isaac stone and a painted ceiling in the mediaeval church, with familiar gravestone symbols on it. Signposted from main road halfway between Grandtully and Aberfeldy.

Perth, Greyfriars (OS58: 120233). In the town centre beside a car park. A 'top three' choice, perhaps the very best. Some of the special stones have been moved under shelter and are well-described, the finest such grouping in Scotland, but the whole graveyard is full of fascinations – allow plenty of time, and photographers will want both morning and afternoon light. The prime stones in the shelter are described helpfully.

Rhynd (OS58: 182185). Ferrymen and fishermen, blacksmiths at work, a small collection but all out of the ordinary – once you find the site. It is not at the Rhynd name on the map. Leaving Bridge of Earn, heading north, turn right after crossing the bridge. When the road turns sharp left to go uphill, turn off right: the graveyard is at the end of this road.

Kinfauns (OS53 or 58: 166223). A fine setting high above the Tay round a ruined old church and an abandoned Victorian church. Some fine stones with figures (Adam and Eve a bit damaged). Early Charteris Aisle. *St Madoes* (OS53 or 58: 196212). Ploughs, animals and other unusual stones. *Errol* nearby, to the east (OS53: 253226) also worth visiting; graveyard up side-road off town centre.

Dundee, The Howff (centre of city, OS54: 400303). Historic city setting. Check Museum for a guidebook. Many trades (symbols or not) can be listed. Fascinatingly crowded site.

Abernyte (OS53: 268311). East of Abernyte village. The famous (gruesome) butchers' stones, Tree of Life, etc. All the interests face

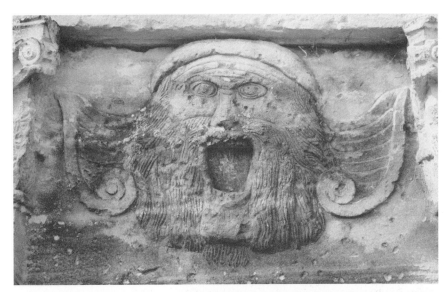

137. Humour and horror: 'The Scream' at Liberton (1737, top),
the sixteenth-century skeleton in Benholm Church (Kincardineshire,
left) and one of the impish faces at Dalgety Bay (1755, right).

west. **Lundie** (OS53: 291366). Not at the 'Kirkton'! Finest Adam
and Eve/Abraham and Isaac stone, good cordiner, farm animals, etc.
Tealing (OS54: 413380) has old doocot and prehistoric souterrain.
The graveyard is at the **Kirkton** (OS54: 403379). Well-preserved and
varied collection. Figure in shroud (against wall). In modern section,
many ploughing scenes.

Monifieth (OS54: 495324). Driving north on the A930 through the
town, look out for Church Street, turn left. St Rules is on the right
not far along. An entertaining collection of winged spirits and some

good trade stones. There are plenty of inscriptions and these have been recorded.

Inverarity (OS54: 453443). The beautiful watchmaker's stone and many others of interest and well preserved.

Logie Pert (which is at North Water Bridge, OS45: 650660). Best known for the Buchanan Stone, which stands (frustratingly) in a protective cage, but there are several others of interest, including some unusual weavers' stones.

> *Eternity is*
> *A wheel that turns*
> *A wheel that turns for ever*
> *A wheel that turns*
> *And leaveth turning never.*[92]

Notes

∽∂)C∂

1. In Perth Greyfriars kirkyard, on a stone for John Gow, d. 1857.

2. A day-conference on the subject of gravestones is held every two years at Kirkcaldy. (The 2004 gathering was one spur towards the production of this book.) 2006 was equally enjoyable. Anyone interested in future events can get in touch with Ann Watters, tel: 01592-266361.

3. The sources of these are given in abbreviated form, thus 1 Cor 15:20 indicates the First Epistle of Paul to the Corinthians, chapter 15, verse 20, a system which even those unfamiliar with the Bible can soon work out.

4. A similar sort of adulatory connection occurred more recently. In August 2006 a monument was erected in Piershill Cemetery to Colour Sergeant Donald McNab (d. 1893), Royal Engineers attending the ceremony. The inscription notes his having been *Friend of Greyfriars Bobby*. (He apparently bought meals for the stray when it wandered close to where he lived.)

5. Dane Love, *Scottish Kirkyards* (Hale) 1989, has a chapter which covers 'Early Times' and much else of interest which is outside the scope of this work, a recommended read as the best general book on the topic to date.

6. Scoonie is an inland attachment of Leven, across the coast road from Letham Glen park. OS59: 383016.

7. A surprising number of aisles have outlasted the churches they once stood beside: the Bruce Aisle by Loch Leven (Kinross) now stands among yews; at Kinnoul (Perth), Tranent, Lasswade and Alloa (Greenside) the churches have gone. At Greenside the Earl of Mar and Kellie had a well known architect Gillespie Graham build a sumptuous aisle in 1819. The church is a ruin. There are two huge aisles beside the church at Methven, much photographed.

8. 'So quickly passes the glory of the world.' Thomas à Kempis (d.1471): *Imitation of Christ*. I'd much like to know the location of this stone.

9. The quote is from the *Edinburgh* volume in the Pevsner-style *Buildings of Scotland* series, an indispensable aid, covering many parts of Scotland. The *RIAS* guidebook says he was buried (in 1848) six weeks after his death, forty feet down, entombed in stone, called a 'Singular Interment' in the papers of the time. Twenty feet or forty feet down, he made sure nobody would dig up or observe his body.

10. Lord Cockburn quotes this in his book *Circuit Journeys*. It was on the burial place of *John Geddes, glover, Burgess in Elgin, and Issobel McKeian, his*

spouse, and their relations. Cockburn himself had a monument erected to the memory of a shoemaker, John Shanks, who cleared the mess out of the ruined Cathedral and looked after the neglected monument for seventeen years. The words quoted appear the length of Britain, but none earlier than here.

11. Mercury's wand with the two entwined snakes has become the emblem of physicians.

12. At West Wemyss, in and left, there's a red granite stone for Johan (Salmond) who died, aged 4, on this 'date' in 1877. April 31 is also inscribed as the date on a stone at Sanquhar to an Isabella Gilmour (1862). Leaving a date blank for completion later can't be too unusual. I met a gentleman in the Dean who has erected a stylish modern stone for his wife – and himself. His date of birth is shown, then a dash. He strolls in now and then to keep an eye on his lair.

13. OS54: 715539 (the bay is named as Todd's Hole on the map).

14. Books frequently refer to it as his only gravestone attempt, but there are two others in the Glasgow Necropolis.

15. Albrecht Dürer, German engraver and painter of astonishing versatility, died 1528.

16.
> *In memory of*
> *Catherine Campbell*
> *Spouse to All*
> *An Henderson*
> *who died...*

17. Odd names: McIllwee (Kirkcaldy Hayfield), MacKellaig (Fort William), McOuat (Baldernock), McLuckie (Campsie), McCaa and McAughtie (Barr), Haddock (Kirkintilloch Auld Aisle), Hurry (Milnathort), Hush (Liberton), Heart (Barr), Hatch (Fort William), Higgie (Kilmany, Fife), High (Tayport), Hiddles (Kirkcaldy Old), Heugh (Anstruther Wester), Hadaway (Scoonie), Scorgie (Kirkcaldy Hayfield), Spankie (Logie), Snowball (Methill), Plank and Fish (Kincardine), Mustard (Tillicoultry), Eyes (Abercorn), Tittle (Dean), Baldy and Foggie (Forgan), Hovelshroud (Rattray), Deadman (Logie).

18. Edinburgh Piershill has a large Jewish cemetery, stones somewhat uniformly arrayed in grey granite, Portobello a Muslim section, quite elegant but with exactly the same sentiments expressed and the same style of decoration as the nearby Christian ranks – and one openly 'gay' inscription.

19. Willsher and Hunter, *Stones* has a chapter on Scottish epitaphs, and Betty Willsher's *Scottish Epitaphs* (Canongate 1996) covers the subject extensively (with many illustrations of artwork as well as texts). Older works of note are C. Rogers, *Scottish Monuments and Monumental Inscriptions* (1872) and the *Proceedings* volumes, notably Christison, *The Carvings and Inscriptions on Kirkyard Monuments of the Scottish Lowlands* (1901-1902 pp. 280-457) and *Additional Notes...* (1905-1906). A sad number of items quoted now can't be

found, but this is not new: Erskine Beveridge in his *The Churchyard Memories of Crail*, published in 1893, has a list of known stones 'which are not now to be found'. The Scottish Room in Edinburgh Central Library (George IV Bridge) has these available and many more recent local surveys of graveyards. A recent general collection is Nigel Rees, *I Told You I Was Sick* (Weidenfeld and Nicolson, 2005). The joke inscription of the title first appeared in America. Spike Milligan reputedly asked to have *I told you I was ill* inscribed on his grave, a suggestion vetoed by the family. But it *is* there, though disguised by being in the Irish Gaelic language and script: *Duirt me leat go raibh me breoite.*

20. This last is for Andrew Sharp, cobbler, musician and drawing master. The steeplejack epitaph is supposedly in Lilliesleaf (Rogers) but careful searches never found it.

21. The graves/inscriptions at Barr are numbered/listed in a guide: John Campbell 89, Edward McKeen, 108, the rhyme *How lov'd, how value'd...* 239. The rhyme *Infinite Joy,* 219.

22. This I saw attributed to Kirkcaldy Parish Church, but none of my local experts have seen it there. We would very much like to know the location.

23. I've seen differing versions and attributions for this rhyme, so it could be apocryphal. The Eppie Coutts rhyme couldn't be found on site. Stones, alas, do disappear. Even Rogers, who quoted this rhyme, complained frequently about stones that had gone.

24. Irons, blacksmith (Kilmore, Mull), Hay, farmer, (Kinross, Loch Leven), Tawse, schoolteacher, Kilninian (Mull).

25. Noted by Cockburn at Inverary and also at Dundrennan (and two in Herefordshire). I've met it at Tulliallan (Kincardine).

26. This was recorded in 1843 but cannot be found today.

27. The defensive enclosure in the foreground of the St Cyrus picture is for a 39-year-old Victorian lawyer, George Beattie, who, jilted in love, shot himself at this spot in 1823. A watchhouse was needed here and at other coastal places, to stop bodies being taken off by boat to Aberdeen or Edinburgh.

28. The site is actually beside Airth Castle and I'm told is being restored. The mort safe is at the back of the ruined church. (OS65: 898867)

29. There was a similar one used at Inverurie, but grave-robbers then dug down past one end, prised the end off the coffin, tied a rope round the neck of the corpse and dragged it out. Some of the mort houses in the north east of Scotland were underground or semi-underground, and mortsafes had a flat slab of iron with an iron apron of spikes round it which was hammered into the ground to protect the coffin, (Skene, Towie, Cluny).

30. I first read this in a well-researched book *Scottish Bodysnatchers* by Norman Adams (Goblinshead, 2002).

31. The first great gathering to sign the National Covenant was in Greyfriars churchyard in Edinburgh. (Table stones have their uses!) Later something like

a thousand Covenanters were herded into an area of the graveyard and held in appalling conditions with no shelter, hygiene or food.

32. Ironically, a few hundred yards from the pyramid marking this assassination spot on Magus Moor near St Andrews there are the graves of Covenanters killed in revenge after the Battle of Bothwell Bridge (OS59: 456151 and 455151).

33. Muirkirk lies on the A70 from Edinburgh to Ayr. From Muirkirk the A723 heads north and after two miles a track branches off, right, to run up to Priesthill. There's a car park on this road. The Martyr's Grave lies on the fell above and is on the OS map (a small enclosure with the gravestone): OS71: 730314. On a walk to this spot one can easily imagine the sad past of Covenanting days. (The epitaph is an acrostic on Brown's name.)

34. Old Mortality was Robert Paterson, who spent much of his early life in Nithsdale where he became interested in the graves of Covenanters and started to place gravestones over them with his own idiosyncratic wording – he was a mason. This task became obsessive, and he left home and family to travel the length of the land marking such sites. He even met old survivors of the Killing Times. Sir Walter Scott ran into him at Dunnottar and later sought to see a stone was raised over his grave, without success, but after Scott's death his publishers found the grave and erected the stone, at Bankend of Caerlaverock, *Erected to the memory of Robert Paterson, the Old Mortality of Sir Walter Scott, who was buried here, February 1801.* At Balmaclellan there is a sculpted memorial of Old Mortality lying at work while his horse stands patiently by.

35. A recent book which comprehensively covers this topic is Dane Love: *Scottish Covenanter Stories* (Neil Wilson Publishing, 2005).

36. Rev.20:12. 'The dead... stand before God, and the books were opened, which is the book of life...'

37. 'Twiddly bits' my mother called finials, the decorative piece on top of a spire, roof, gravestone, etc.

38. The portrait shown is of one David Scott, 1807-1849, a popular artist in his day for historical subjects such as *The Traitor's Gate*. The Dean has many artists buried there: Sam Bough, Noel Paton, the Nasmyths, George Chalmers, E. A. Walton, Robert Hutchison, James Paterson, William Allan, George Harvey and Octavius Hill.

39. William MacGillivray (d. 1852) produced the first book detailing the *History of British Birds* and was a professor at Aberdeen University. Rising from an impoverished childhood he once *walked* to London and back to further his education.

40. At Kirkton of Glencairn, near Moniave, there is a stone to a centenarian who died in 1663, delightfully crude lettering, and the date shown 16∂ε.

41. Wanlockhead. The full inscription reads: *Sacred to the memory of Robert Taylor many years an overseer for the Scottish Mining Company at Leadhills and*

died May 6th 1791 in the 67th year of his age. He is buried by the side of his father John Taylor who died in this place at the remarkable age of 137 years. A stone at Sanquhar for a Robert Brown shows him dying at the age of 180, but this is just a 'misprint' for 80. These notes are of my own discovering, but Dane Love in his *Scottish Kirkyards* (Hale, 1989) covers the topic more thoroughly, with ages of 106, Roxburgh; 108, Preston (Berwick); 110, Braemar; 114, Dunbar; 128, Inverlussa (Jura). This reminded me of the story about Peter Grant of Braemar who had fought at Culloden and, years on, aged 106, petitioned George IV for a pension, claiming to be 'His Majesty's oldest foe'.

42. For centuries not to be buried in consecrated ground was regarded as a disaster; entrance to heaven depended on it. So no animals of any kind would be admitted (or certain people if it came to that – such as suicides).

43. OS59: 328067, Colzium OS64: 728782.

44. Genesis 1:26. 'And God said, Let us make man in our image, after our likeness: and let them have dominion... over all the earth and over every thing that creepeth upon the earth.'

45. The ultimate of this swank is the Pineapple, a folly, several stories high, at Dunmore, off the A905 between Stirling and the Kincardine Bridge.

46. Boat launches seemed to be unchancy events. At Kippen there's a stone to *James Hall, Drowned at Goven at the launching of the Daphne, July 1883, aged 10.*

47. Wooden sailing ships had little chance of escape if they 'took the ground'. The *Merlin* hit the rocks by the castle and broke up below the cliff-top lined with helpless spectators. Salvaged wood was turned into souvenirs like stools, picture frames and walking sticks.

48. Just how dangerous the sea can be is starkly shown on a stone at St Andrews: *Erected by William and Esther Wallace (in 1836) in memory of their eldest son Captain David Wallace, died at Hamilton and buried here 1834, John their second son, drowned in London River aged 16 (1803), Catherine, eldest daughter, died in infancy, William, third son, commander of brig Rival of Greenock who perished with all on board on the coast of Ireland 1832, aged 33 and Thomas, fourth son, who was drowned in the River Amazon (1815) aged 21.*

49. On the train were 485 officers and men of the 7th Battalion of Royal Scots. 214 perished. Those who survived went on to Gallipoli. The cross of the memorial over the common grave in Edinburgh is of red Peterhead granite, modelled on St Martin's Cross in Iona. Many men came from the area. The striking memorial is in the far right corner of the cemetery.

50. The accident is thoroughly investigated in I. D. S. Thomson, *The Black Cloud* (Ernest Press) 1993, which covers seven Scottish mountain 'misadventures'.

51. The impressive marble group was the work of Handyside Ritchie, who is probably best known for his figures of Reformers and Covenanters which are scattered about in Stirling's Holy Rude burial ground.

52. Mark 10:14. (Matthew 19:14 has the same quote but ends 'Kingdom of Heaven'.)

53. The text is in Latin. The 600 may not be exact, 600 at that time being a shorthand often used to indicate a very large, but unspecific number. The remnant of the 1647 original is by the west gate of the graveyard, and a decayed 1869 reproduction stands inside the cathedral at the base of the Round Tower.

54. This story was researched more recently and a booklet privately published: Dominic Currie, *Dark Skies Over School Wynd*, 1998.

55. Other costume figures: Sorn, West Linton, Tealing, Stobo, Abernyte, Perth Greyfriars, the Howff (Dundee), Pencaitland.

56. I've seen winged spirits with bare breasts at Edinburgh St Cuthbert's and Liberton.

57. They are on the stone to a local fashionable hat-maker John Morton (d. 1739).

58. *Memento mori*: Remember you die/Remember Death; *Hora fugit*: Time flies; *Disce mori*: Learn you die; *Requiescat in pace* (R.I.P.): Rest in peace. There are hundreds of *Memento mori* for any other tag.

59. Winged hourglasses seem to come in rashes at individual graveyards – Stirling Holy Rude and those in Galloway. (Odd ones at Inveresk, Peebles, Falkland.) At Crowdieknowe there's a winged stirrup; so what was that intended to convey?

60. At a later date than this rondel scene a female, buried in this lair, was nearly removed by bodysnatchers to sell to a local medical student. They were apprehended. The medic fled to the continent, and through a slip-up in procedures the men were released. A mob came to the house of one, but a policeman quickly took him off to prison again; the other fled over the rooftops and had to be escorted to prison by an armed escort from the castle. This did not stop the mob, and a full scale riot ensued. Resurrectionists were not popular.

61. The first is for Sir John Preston of Airdrie, who was a student at St Andrews when he died in 1657, aged 26, the second commemorates a daughter of Turnbull of Bogmill, d. 1650, whose large decorative slab stands beside it with a bull's head shown turned aside. Puns are nothing new.

62. The Grandtully site is actually half a mile up a side road off the A827 midway between Grandtully and Aberfeldy. Signposted *St Mary's Church*, which is a mediaeval building with a splendid painted ceiling depicting plenty of scenes familiar on gravestones: angels of the Resurrection, a skeleton (death) stabbing a man lying in his bed etc. The graveyard has little of interest except the magnificent Abraham and Isaac stone: this is situated just to the right after entering the gate (behind the church). OS52: 886506.

63. Poor people could not afford a coffin and might be buried in one with an opening bottom so it could be lifted after the burial ceremony. Vagrants would

be lucky to have a winding sheet, and at times of plague everyone would be unceremoniously dumped in a communal pit.

64. I noted this on the grave slab of George Greig, in Leslie's Kirk on the Green, but it can be found elsewhere as well. The words were composed by Ebenezer Erskine.

65. One I noted down at Monifieth, below a winged spirit who seemed to sport a beard, went: *All men live in the same death power / Who seized my beloved in an hour / One word to me he could not speak / Though floods of tears ran down my cheek.* Another sad one went *Here lyes a hermles bab / Who only came and cryed / In baptism to be washed / And in three months old he deyed.*

66. 1 Cor. 15:52. 'In a moment, in the twinkling of an eye, at the last trump, for the trumpet shall sound, and the dead shall be raised incorruptible, and we shall be changed.'

67. These quotes come from 1 Cor. 9:25, 1 Tim. 4:8, 1 Pet. 5:4.

68. The stone is for a baxter (baker) and the east face shows their symbolic wheat sheaves and balance – see p. 116. The stone is hidden among trees, up right when coming in the main driveway.

69. A 1707 table stone at Irongray for Bessie Edgar shows a figure holding an open book, inscribed

THE	W
ORD	
OF	
GO	D

Another on the wall of St Michael's, Dumfries, states the book is the Bible.

70. A Newtyle farmer's stone, 1762, has these flanking torches as well as the stone being topped by a crown and winged spirit and having sock and coulter in a mock coat-of-arms. The reverse has the following: *What vain desires, what passions vain / Attend thy mortal clay / Oft have they pierced my soul with pain / And drawn my heart astray / Now death at last has closed my eyes / To part with every lust / I charge my flesh when it shall rise / To leave them in the dust.* The **N** completing the first line was missed out and squeezed in later.

71. The rose also had a meaning of Paradise, an Islamic symbolism brought back by the Crusaders.

72. 'I know that my redeemer liveth... And though after my skin worms destroy this body, yet in my flesh shall I see God.' (Job 19:25, 26)

73. A stone at Lockerbie can no longer be found, alas, for it had the inscription *Here stands Adam and Eve, tree and all / Whereby whose fall / We were made sinners all.* The Methven stone bears the words *Thus was the way that sin began / Woman she beckoned unto man.*

74. I spent so long wandering about Logie Pert (north Angus) searching for a graveyard that I was accosted and asked my business – which then

rather surprised the questioner, but she was able to indicate the graveyard I wanted was at North Water Bridge, just off the A90 Dundee-Aberdeen road, the North Water being the North Esk. (OS45: 650660)

75. The King James Version (Genesis 22, abbreviated) reads: 'And it came to pass after these things that God did tempt [i.e. test] Abraham... he said Take now thy son, thine only son Isaac, whom thou lovest, and get thee into the land of Moriah; and offer him there for a burnt offering upon one of the mountains. And Abraham rose up early and saddled his ass and clave the wood for the burnt offering, and went unto the place of which God had told him. And Abraham took the wood and laid it upon Isaac his son; and he took the fire and a knife; and they went both of them together. And Isaac spake, My father, behold the fire and the wood; but where is the lamb for a burnt offering? And Abraham said, My son, God will provide. And they came to the place and Abraham built an altar and laid the wood in order and bound Isaac his son, and laid him on the altar upon the wood. Abraham stretched forth his hand and took the knife to slay his son. And the angel of the Lord called, Abraham, Abraham: and he said, Here am I. And he said, Lay not thy hand upon the lad for now I know that thou fearest God seeing thou hast not withheld thine only son from me. And Abraham looked and behold behind him a ram caught in a thicket by his horns, and Abraham took the ram and offered him up for a burnt offering in the stead of his son.'

76. Forensic scientist (Portmoak), Milk Officer (Mull, Pennygown), Linguist (Logie New), Beadle (Corstorphine), Lithographer (Glasgow Necropolis), Fireman (Kirkcaldy Hayfield), Dancer (Logie New), Organ builder (Edinburgh Dean), Radiographer (Mull, Kilmore), Cartographer (Dean), Amusement Caterer (Edinburgh Piershill), Papermaker (Kinkell, Inverurie), Golf Club Manufacturer and Oil Rig Worker (Kinghorn).

77. The swingletree was the crossbar that could pivot in the middle to which the traces were attached at the outer ends, linking horse and plough. The yoke was the piece fitted over the neck/front of the horse into which it put the driving force of its forward movement.

78. In the new cemetery at Kincardine (off the A985 heading east: OS65: 938873) there is a stone which stylishly reproduces and updates this old tree-felling picture, and the text from Ecclesiastes. The full Biblical text reads: 'If the clouds be full of rain, they empty upon the earth and if the tree fall toward the south or toward the north, in the place where the tree falleth, there it shall be'.

79. A competition was held to find the best epitaph and was won by the local minister. In full it read: *Ah John [Murray] what change since I saw thee last / Thy fishing and thy shooting days are past / Bagpipes, and hautboys, thou canst sound no more. / Thy nods, grimaces, winks and pranks are o'er / Thy harmless queerish incoherent talk, / Thy wild vivacity and trudging walk / Will soon be quite forgot; thy joys on earth / A snuff, a glass, riddles and noisy mirth / Are vanished all. Yet blest I hope thou art / For in thy station, weel thou play'dst thy part.*

80. A quaich is a shallow, two-handed drinking cup; cutler is found on a stone in Edinburgh Canongate.

81. In heraldry, a sheaf of corn was a *garbe*. Many of the trade symbols shown within shields were not authorised and had no legality but no doubt pleased their creators.

82. A candlemaking family is mentioned on the stone. *James Alison, candlemaker in Dunnikier died with other nine… through a fatal fall of stones from the upper part of a cave on the south side of this town.*

83. The banner of the Dunfermline weavers' guild which was paraded through the town annually showed a boar's head with a shuttle in its mouth.

84. Dingwall, Invekeilor, Ayr (Forgan) and Kirkmaiden have other examples and versions.

85. There was one at Crieff (wig stand, razor box, hand holding a razor) but the local authority removed all the recorded old stones and erected on their pseudo lawn a fatuous monument to *all those who now have no marked grave.* Ignorance is no excuse for such mindless vandalism.

86. A mural monument at Crail to a schoolmaster James McMin has the following: *The benefit of whose superior /talents was long experienced in this / burgh, where he taught the principal / school for 40 years. Died 19 Nov^r / 1819 Aged 69 / This monument was erected in the year 1829 / by a number of his scholars, / as a grateful tribute of respect.*

87. 'A sweet and noble thing it is to die for your country.' A quote from Horace and perhaps we believed it – then – till Wilfred Owen used it for the title of a poem.

88. The 'compass rose', Tayport.

89. I have a picture of everything mentioned in these lists.

90. One of the most popular monuments in the graveyard at St Andrews Cathedral is to Tom Morris, the younger, the famous golfer (he won the Open aged 16 in 1863 and went on to win in three successive years) who is shown life-size, addressing a ball. On the ground you may see two or three golf balls and, no matter how often these are cleared away, others always soon appear. Allan Robertson, Old Tom Morris, Andrew Kirkcaldy and Willie Auchterlonie are other great Victorian golfers buried here. Scots went to England and the USA, introducing the game and designing courses – so Auchterlonie's 1893 was the last Scottish win in the Open.

91. I have photographs of all these too but will not betray their location; the like can be found in any cemetery in use today.

92. On a miller's stone at Clachan of Campsie, Dunbartonshire (OS64: 610795, though I failed to locate another Rogers report in this atmospheric old graveyard.